Close Observation

"*There can be neither harm
nor disappointment in the
close observation of nature.*"

Thoreau, *Walden*

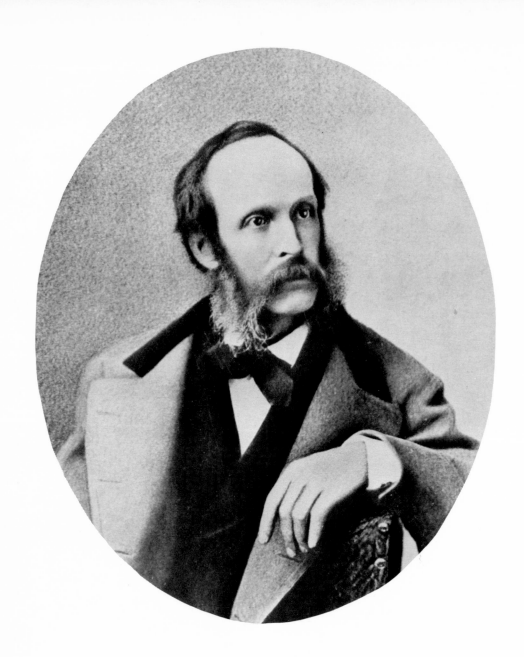

Close Observation

Selected Oil Sketches by

Frederic E. Church

from the collections of the Cooper-Hewitt Museum,

the Smithsonian Institution's National Museum of Design

THEODORE E. STEBBINS, JR.

Museum of Fine Arts, Boston

Smithsonian Institution Press

Washington, D.C.

© Smithsonian Institution, 1978

Library of Congress Cataloging in
Publication Data

Church, Frederic Edwin, 1826-1900.
 Close observation.

 Includes bibliographical references.
 1. Church, Frederic Edwin, 1826-1900—
Exhibitions. I. Stebbins, Theodore E.
II. Cooper-Hewitt Museum of Decorative Arts
and Design. III. Smithsonian Institution.
Traveling Exhibition Service. IV. Title.
ND237.C52A4 1978 759.13 78-16111

ISBN 0-87474-887-9 (paper)
ISBN 0-87474-888-7 (cloth)

COVER: Cat. No. 32.
Niagara from Goat Island; Winter.

BACK COVER AND FRONTISPIECE:

FREDERIC E. CHURCH, 1826-1900.

Photograph, ca. 1860, from *Frederic Edwin
Church,* National Collection of Fine Arts
Exhibition Catalog, Smithsonian Institution,
Washington, D.C., 1966.

Designed by Gerard A. Valerio, Bookmark Studio

MUSEUMS PARTICIPATING IN THE TOUR

MUSEUM OF FINE ARTS
Boston, Massachusetts

UNIVERSITY ART GALLERY
University of Pittsburgh
Pittsburgh, Pennsylvania

ULRICH MUSEUM OF ART
Wichita State University
Wichita, Kansas

UNIVERSITY OF MICHIGAN MUSEUM OF ART
Ann Arbor, Michigan

ELVEHJEM MUSEUM OF ART
University of Wisconsin
Madison, Wisconsin

CORCORAN GALLERY OF ART
Washington, D.C.

BRUNNIER GALLERY
Iowa State University
Ames, Iowa

NELSON GALLERY—ATKINS MUSEUM
Kansas City, Missouri

COOPER-HEWITT MUSEUM,
The Smithsonian Institution's National Museum of Design
New York, N. Y.

Table of Contents

Acknowledgments

ANNE R. GOSSETT

Program Officer
Smithsonian Institution
Traveling Exhibition Service

The Smithsonian Institution Traveling Exhibition Service is pleased to make possible the tour of these selected works by Frederic E. Church. We hope that the circulation of the exhibition will increase public appreciation of Church's oil sketches, both as finished expressions of the artist, and as integral steps in the preparation of large-scale panoramic paintings. Additionally, the tour will enable several of the participating museums to present these works in relation to works in their own permanent collections. The circulation of this exhibition is especially important to the Traveling Exhibition Service in that it allows us to fulfill our primary goal of making available the collections of the Smithsonian to the Institution's national constituency.

Through its generous loan, the Cooper-Hewitt Museum of Decorative Arts & Design has made this exhibition possible. Lisa M. Taylor, director, and Elaine Evans Dee, curator of drawings and prints, have given enthusiastic support in all phases of planning. The Museum of Fine Arts, Boston, has contributed to the successful realization of the project by permitting Theodore E. Stebbins, Jr., to be the guest curator for the exhibition.

From the staff of SITES the following persons have given their special talents to the many aspects involved in the development of a circulating exhibition: Marjorie Share, education coordinator; Eileen Harakal, public information officer; Andrea Stevens, publications coordinator; and Emily Dyer, registrar.

Finally, Dennis A. Gould, director of SITES, joins me in emphasizing the importance of the cooperation of other offices and bureaus of the Smithsonian in this endeavor. The Office of Exhibits Central has edited the interpretative materials as well as designed and produced the exhibition itself. The Smithsonian Institution Press has published this catalogue with SITES. The Office of Membership and Development has selected the catalogue as the 1978 publication for contributing members of the Smithsonian National Associates.

Preface

Theodore E. Stebbins, Jr.

Curator of American Painting
Museum of Fine Arts, Boston

Any investigation of Frederic Church's work must inevitably rely on the pioneering researches of David C. Huntington. His unpublished doctoral thesis of 1960, which still provides the basic biography on Church, marks the modern rediscovery of this extraordinary American artist. Professor Huntington's subsequent book of 1966, *The Landscapes of Frederic Edwin Church,* and the exhibition catalogue he and Richard Wunder compiled in the same year for the National Collection of Fine Arts reflect increasing interest in the artist. This interest has grown over the intervening years, and small groups of Church's works in various media have now been exhibited on numerous occasions.

The oil sketches have attracted special notice. Their quickness, their succulent paint quality, their careful recording of both the common and the exotic appeal to contemporary taste. E. P. Richardson called them "little miracles of observation," and many others have delighted in singling them out for our attention. But the critics have ventured no farther. There has been only slight investigation of Church's method as revealed by the sketches, and little consideration of the great development, over his long career, of his style and vision. The oil studies and sketches are not only supremely beautiful in themselves, but they can tell us a great deal about Church's art and the art of his time.

The present exhibition of 112 works has been selected from the group of more than five hundred oil sketches that were given in 1917 by the artist's son, Louis P. Church, to the Cooper Union Museum for the Arts of Decoration, now the Cooper-Hewitt Museum of Decorative Arts & Design, Smithsonian Institution. This holding represents the vast bulk of Church's surviving work in this medium. In addition, there remain some 150 at Olana, the artist's great home on the Hudson, and there are a handful that have descended through his family and are now owned by private collectors.

The exhibition itself was initiated by William Kloss, who oversaw its early stages until leaving SITES in April 1978; since then it has been capably overseen by Anne R. Gossett. The project has been very much a collaborative effort between myself, Elaine Dee, who, as curator at the Cooper-Hewitt, has answered every request with unfailing skill and good humor, and Elizabeth Prelinger at the Museum of Fine Arts. Ms. Prelinger compiled the catalogue listings and has been indispensible as research assistant. We are grateful indeed to the staffs at SITES, the Smithsonian Institution Press and the Museum of Fine Arts, to Linda McLean at Olana and to the many others who have answered our requests for information and photographs. We also acknowledge with thanks Brayton Wilbur, Jr., for an initial planning grant in support of the project.

Close Observation

Introduction

Frederic Church had no rival in American art at mid-century. If Thomas Cole (1801–1848) was the founder of the Hudson River School and the popularizer of landscape painting, Church, as his student and successor, developed realistic landscape to its highest point in the years just before the Civil War. When Church's great *Niagara* (Corcoran Gallery of Art, Washington, D.C.) was first exhibited in New York in April 1857, few would have disagreed with the critic who proclaimed it "incontestably the finest oil-picture ever painted on this side of the Atlantic."[1] Then, in 1859, Church painted *The Heart of the Andes* (The Metropolitan Museum of Art, New York), sold it for $10,000, at that time the highest price ever paid to a living American artist,[2] and saw it draw great crowds and effusive critical praise during its exhibition in New York, Boston and London. Viewing him as J. M. W. Turner's natural successor, London's *Art Journal* commented: "On this American more than any other . . . does the mantle of our greatest painter appear to us to have fallen."[3]

The painters of the Hudson River School believed passionately in the close study of nature. In codifying general practice, Asher B. Durand advised the young painter, "Yes! go first to Nature to learn to paint landscape, and when you shall have learnt to imitate her, you may then study the pictures of great artists with benefit."[4] Though the finished pictures were normally made at their studios in New York or elsewhere during the winters, the Hudson River School painters spent long summers traveling widely and sketching in pencil, charcoal and oil. They revered nature and, in her, sought worthy subjects for their canvases. The sweep of the landscape appealed to them as much as did the details that made nature beautiful. They responded to the mossy rock, the perfect elm or birch and the rare wildflower as surely as to the panoramas of mountain passes and picturesque lakes. In nature they found *what* broad views to paint as well as *how* to paint them. They echoed Gilpin in believing that ". . . he who has seen only one oak-tree has no compleat idea of an oak in general; but he who has examined thousands of oak-trees must have seen that beautiful plant in all its varieties; and obtains a full and compleat idea of it."[5]

The necessity of sketching from nature could be shown interchangeably on esthetic, scientific or religious grounds. Nature, and particularly wilderness, represented truth; civilization was suspect. The definition of plant and animal species, the exploration of boulder and mountain streams brings us closer to God's handiwork, to revelation. These painters, and Church above all, believed in the Transcendentalist attitude and in Thoreau's admonition: "There can be neither harm nor disappointment in the close observation of nature."[6]

It was possible, of course, to study nature closely and to paint topographically accurate land-

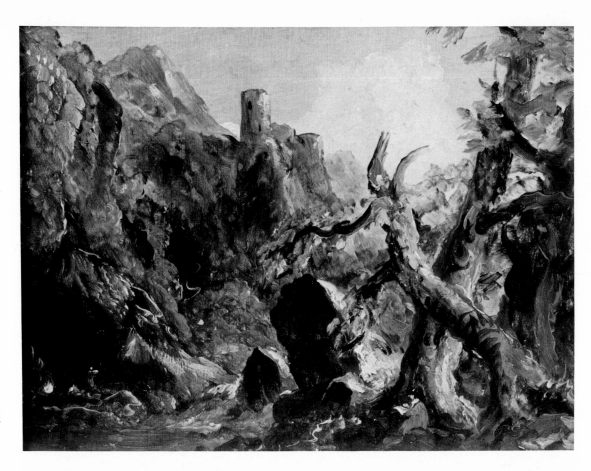

PLATE 1.
Thomas Cole, SALVATORE ROSA SKETCH-
ING BANDITTI, *ca.* 1832–1840, oil on wood
(Museum of Fine Arts, Boston. M. and
M. Karolik Collection.)

scapes without making oil sketches. The pioneer American landscapists, John Trumbull and Ralph Earl, working during the first years of the nineteenth century, apparently based their efforts on memory and occasional rude outline sketches in pen and pencil. Members of the next generation, including Thomas Doughty, Alvan Fisher and Thomas Cole, drew better and more often. Of these founders of the Hudson River School and thus of professional landscape painting in America, only Cole made oil sketches, and he did so relatively infrequently.

Nonetheless, Cole's sketches are important for Church: they provided the model he followed as a student, and from them he learned the possibilities of the medium. Cole's oil sketches are small, only rarely as large as eight by twelve inches, and they are most often painted directly on wood panels. Typical is Cole's *Salvatore Rosa Sketching Banditti* (plate 1). In this oil panel, juicily and quickly painted, the artist exercises his hand and his imaginative intellect in the creation of a compositional idea. If the format had pleased artist or patron, either at the time of execution or even years later, it might have become the basis for a larger, finished oil. Other Cole sketch subjects included heads and full figures as well as landscape views, both realistic (there is

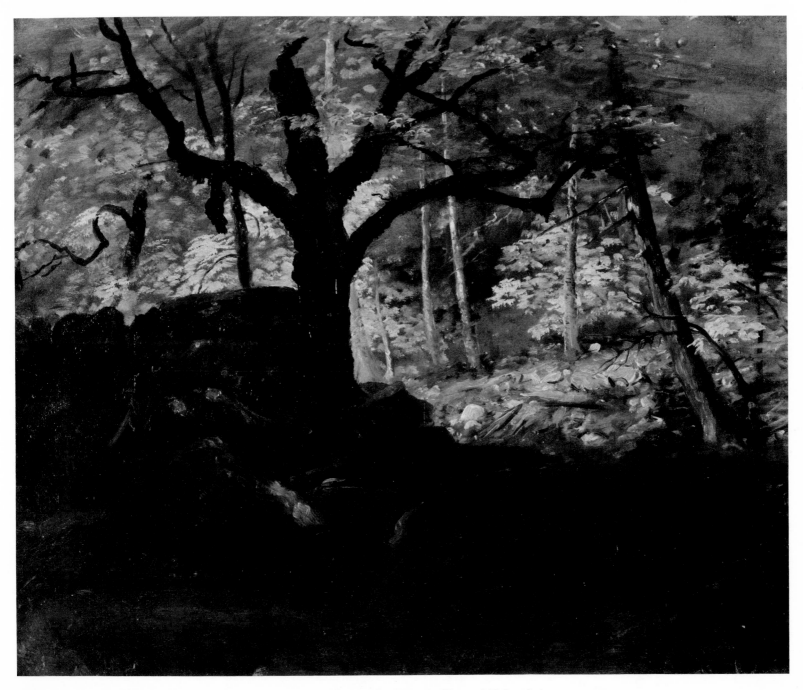

PLATE 2. Thomas Cole, LANDSCAPE (verso), *ca.* 1835, oil on wood (Fogg Art Museum, Harvard University)

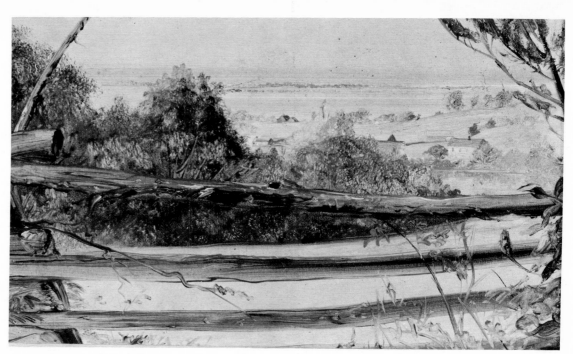

PLATE 3.
William Sidney Mount, THE FENCE ON
THE HILL, *ca.* 1845–1850, oil on wood
(Museum of Fine Arts, Boston. M. and
M. Karolik Collection.)

one for the *Ox-Box*) and imaginary (the ones for *The Departure* and *The Return*). A few are oil on paper, mounted at an early date (possibly even by Cole) onto canvas, but these do not differ in any other way from his norm. Most of Cole's sketches are studio products. Figure studies aside, these studio products are largely what the French would have called *esquisses,* or initial "ideas" for paintings. However, there are also a handful of larger sketches, such as the two-sided panel at the Fogg Art Museum (plate 2), which are color and foliage studies and which may well have been made outdoors late in Cole's life. In the continued use of the heavy panel and in the emphasis even here on rather general notions of form and color, Cole makes it clear that he had not conceived of the full potential of the oil sketch on paper as an essential medium for the roving painter. He preferred the use of detailed pencil drawings of trees, rocks and natural topography. The oil sketch from nature made him nervous, for he commented in a letter to Robert Gilmor: "finished [oil] sketches are never more than half true—for the glare of light destroys the true effect of colour and the tones of Nature are too refined to be obtained without repeated painting and glazing . . ."[7]

William Sidney Mount (1807–1868) described sketching outdoors with Cole in his journal of April 1848: "I have sketched and painted with him in the open air and rambled about the mountains after the picturesque." Though he implied that the older artist made occasional oil sketches outdoors, he also confirmed Cole's preferred technique: ". . . he made a hasty sketch with pencil of every interesting sunset or sunrise, with remarks as regards color and effect."[8] This traditional use of written "remarks" or color notes also marked Church's detailed pencil drawings in the late

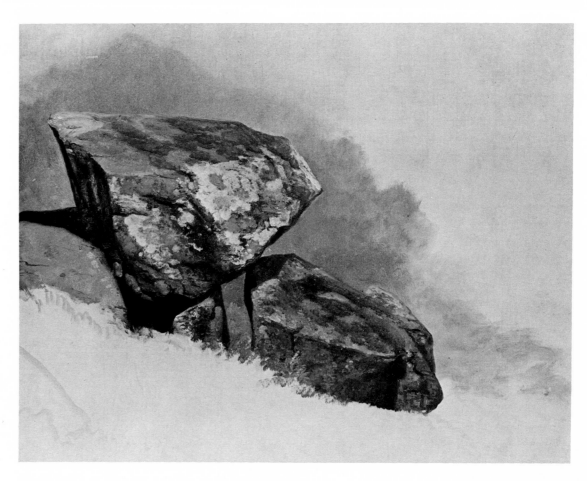

PLATE 4.
Asher B. Durand, STUDY OF A ROCK, *ca.*
1850–1855, oil on canvas (Yale University Art Gallery, New Haven, Conn.)

1840s and 1850s. At times used contemporaneously with the *plein air* oil sketching technique that he developed, the careful pencil procedure became outmoded for him only in the 1860s.

Though essentially a genre painter, Mount may have been more advanced than Cole in his use of the outdoor oil sketch. In his journal for November 1847, he wrote: "Dunlap is right, 'An artist should not confine his observation too much to his paint room.' He should go abroad with his sketch book or paint box, paint on the spot—let him be where he will."[9] Following this advice, during the 1840s Mount made numerous *plein air* oil sketches on panel, all freshly observed. He lacked Cole's powerful reaction to nature, but the ease and informality of his vision (*see* plate 3) may have provided another positive example for Church's excursions into nature.

It was Durand who codified the practices of the American landscape school in an 1855 series of "Letters on Landscape Painting" in the early art magazine, *The Crayon*. Durand, following Ruskin, sent the student "directly to Nature," but he warned him to take "pencil and paper, not the palette and brushes."[10] Members of the Hudson River School followed this code literally, and

though most tried occasional oil sketches, none except Bierstadt and Church made extensive, regular use of the medium. In a sense, Church's sketches and studies in oil carry Durand's theories to their most advanced, logical conclusion. Moreover, Durand's own relatively rare oil studies, executed in the late 1840s and early 1850s, may also have influenced the younger artist, pointing the way to a more detailed technique than Cole could have imagined. Durand's *Study of a Rock* (plate 4) exemplifies his aim for "as minute portraiture as possible of these objects." He explained that, while "it may be impossible to produce an absolute imitation of them, the determined effort to do so will lead you to a knowledge of their subtlest truths and characteristics. . . ."[11] Furthermore, Durand knew Constable's work. He wrote of paying a call to the painter C. R. Leslie in London in 1840, saying, "He showed us several sketches by his deceased friend Constable . . . exhibiting great attention to Nature under her changing aspects . . . among others, a portfolio of studies from clouds and skies in general, with notes on the backs stating the hour of the day, direction of the wind and kind of weather. All his sketches were very slight, but indicating much naturalness and beauty of effect."[12] Durand's own work reflects little of Constable's influence, but he was nonetheless in a position to bring it to the attention of Church and the younger generation.

The *plein air* oil sketch was not an American invention, and Church's devotion to it was not unprecedented elsewhere. One looks to sixteenth-century Italy for the birth of oil sketching and particularly to the Venetians and their practice of painting directly, *alla prima,* onto the canvas without preparatory drawings. Their sketches, like those of Rubens in the following century, were *indoor* products, made in the studio. Use of the (studio) oil sketch gained sufficient status to be codified in French academic practice in the late eighteenth century. For the French academics, as later for Church, a strict distinction was drawn between the unexhibitable sketch, which achieved the freedom and spontaneity of original conception, and the final exhibition piece, which displayed the requisite high finish. A further distinction was observed between the *croquis,* or thumbnail sketch, the *esquisse,* an initial conception of inspiration, and the *ébauche,* the preliminary painted lay-in on the large canvas, the base of the finished painting. The smaller *esquisse* served as compositional and color guide to the final work; studies of details such as drapery and hands, either painted or drawn, were called *études* and were used in compiling the *ébauche* and the final composition itself.[13]

During the first twenty years of the nineteenth century, the practice and theory of oil sketching was revolutionized as Romanticism transformed popular conceptions of landscape painting and of nature itself. God and truth could now be found in the humblest forest fern or in the changing light of a cloudy day. In nature the self could expand, landscape and soul could flow, one into the other. Clearly, the painter would have to paint now, not from memory or imagination, but from observation. An influential essay by Pierre Henri de Valenciennes (1750–1819), "Elements of Practical Perspective . . . ,"[14] appeared in 1800. The author, himself a *plein air* painter, advocated the careful outdoor study of vegetation and architecture. In his own sketches (*see* plate 5), there was, as Boime points out, no attempt to compose, the artist rather "follow[ed] his idea of executing a study within, at the most, a two-hour session . . . he blocked in these works

roughly to determine at the outset the masses and value relations. As a result, the lighting is natural, and all the artifice and theatrical content of his finished works are absent."[15]

The importance of establishing a more direct and diversified relationship with nature was revealed even more strongly in England where the combination of Romantic immersion in nature with a "thirst for objectivity" for the "innocent eye"[16] translated easily into a new enthusiasm for oil sketches. Among the theorists, Gilpin was especially supportive, feeling as he did that "we frequently derive more pleasure and imaginative stimulation from a sketch than from a finished picture."[17]

By the second decade of the nineteenth century, the *plein air* oil sketch was flowering in England at the hands of David Cox, Peter De Wint and, above all, John Constable (1776–1837). Constable believed, as Church would later, that "all pictures should be scientific experiments."[18] Especially in this decade, the skies and their shifting light, the form of clouds and the relationships of trees beneath held a special fascination for Constable; he understood the sky to be the most crucial factor in landscape (*see* plate 6). In his numerous, brilliant small oil studies on paper, Constable explored every coloristic manner of atmosphere, anticipating Church's own not dissimilar

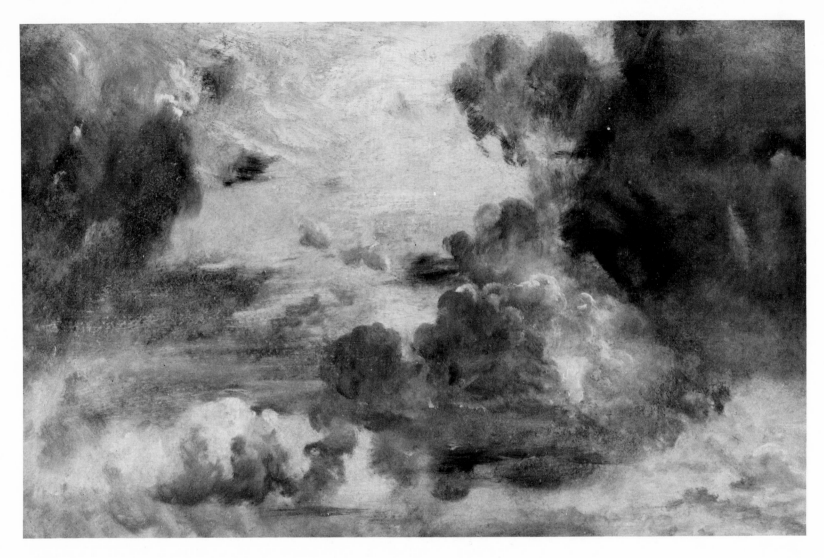

PLATE 6. John Constable, CLOUD STUDY, *ca.* 1815–1820, oil on paperboard (private collection, Boston)

10

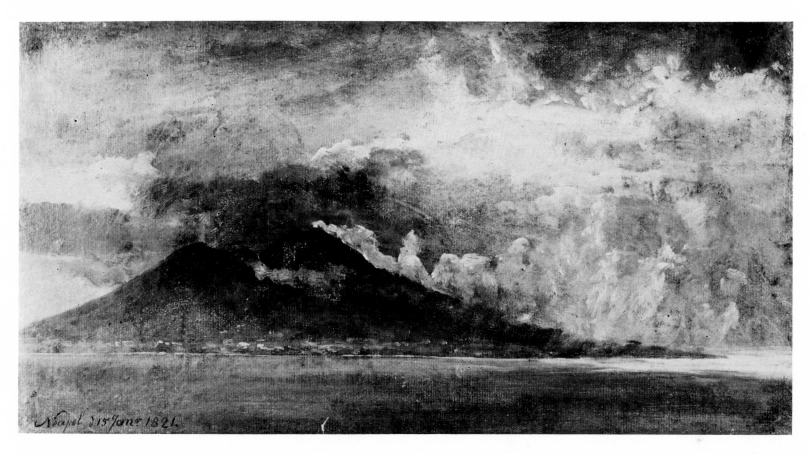

PLATE 7.
Johan Christian Dahl, HEAVY WEATHER OVER VESUVIUS, January 15, 1821, oil on paperboard (Nasjonalgalleriet, Oslo)

efforts of thirty or forty years later. In Constable's hands, the oil sketch became wholly naturalistic. The artist was free to develop the intuitive understanding and the visual vocabulary that would enable him to paint finished pictures. Church came to understand the implications of the English artist's method in a way that Cole simply did not.

Nor was the use of the oil sketch limited to France and England. The study of the literal details of nature and of her changing moods of sunset and storm spread throughout Europe, and was basic to the Romantic *Zeitgeist* of the period. In France, the Barbizon masters were working out-of-doors, and in Italy, the Florentine group of the Macchiaioli was studying light and form directly from nature. It should not be surprising that the oil sketches of the leading Norwegian painter of the times, Johan Christian Dahl (1788–1857), relate both to Constable and to Church. Dahl's oil on paperboard *Heavy Weather over Vesuvius* of 1821 (plate 7) suggests the English master in its loose handling and warm palette and looks ahead to Church's frequent studies of the South American volcanoes, particularly those of Cotopaxi.

11

PLATE 8. Frederic E. Church, WEST ROCK, NEW HAVEN (HAYING NEAR NEW HAVEN), 1849, oil on canvas (The New Britain Museum of American Art, Conn.)

The Early Woodland Studies

Church's earliest oil sketches pay homage to his teacher, Thomas Cole. At Olana there survive two that were doubtless executed during his period of study with Cole at Catskill, New York (June 1844 to mid-1846): *Elm Tree* and *Seated Figure in White*. Both are literal, careful studies, and both are on wooden panels about one-quarter inch thick. The first is of a single green tree in a landscape. The other is essentially a drapery study in which the artist concentrates on the effects of sunlight on a white costume. As one might expect, these early works show the young Church drawing on his master's most advanced technique, for both appear to be *plein air* studies, rather than compositional sketches from the studio, such as Cole usually made.

After Cole's death in February 1848, Church began planning a memorial painting to be called "Apotheosis to Thomas Cole: Vision of the Cross." A series of oil sketches (*see* no. 1) suggests that here Church not only honored his teacher in title and subject but also in the very handling of his medium. Two pilgrims, perhaps metaphors for Cole and Church, sight a cross lit up in a distant, stormy sky. Far more than in the very earliest sketches of Olana, Church here emulates Cole's manner. The sketch is a small one, a studio product, purely an "idea" study. Moreover, the earlier artist's work is recalled in the palette, with its rich yellows and grays, and in the technique, by which the paint is applied in quick, sweeping strokes with a single, wide brush.

Other oil sketches of 1848, such as *Woodland Valley, Autumn* (no. 2), a Catskill scene executed in September of that year, similarly pay tribute to Cole in their subject, in the loose handling and in the pervasive, dense, dark mood. However, this oil sketch also represents an important early stylistic break from his model. Over a third of his sheet is empty, and at the bottom, the only ground visible is the red-orange typically found in his early sketches. His support is, as it would frequently continue to be, a heavy coated paper, "Bristol board," or, paperboard varying in thickness from one-fiftieth to one-twenty-fifth of an inch. The size of the sheet is nearly twelve by sixteen inches, considerably larger than Cole's format but typical of Church's mature sketches as well as those of his contemporaries.

Two Pine Trees (no. 3), *ca.* 1849–50, probably executed on one of the summer expeditions to Vermont or Maine, suggests a far greater step in Church's own developing method. Rather than the composition or scenery, the artist is concerned with the details of nature as seen in a crisp, real light. A sense of intense concentration, of high focus prevails; Church sees nature photographically. (Though photography itself was then in its most primitive stages, the painting prefigures the photographic esthetic of the 1870s and 1880s.) The style exactly parallels that of the great

painting of the same year, *Haying near New Haven* (plate 8). When it was exhibited at the National Academy of Design in New York, *Haying near New Haven* marked Church's coming of age as an artist independent of his mentor.

At about the same time, Church made one of the finest in a series of autumn studies that extends through the mid-1860s. *Autumn Foliage, Vermont* (no. 4) is a minutely treated yet elegantly composed study for *View near Clarendon, Vermont*. The painting was executed in 1850 and now resides in the Olana Collection. Switching to a grayish-brown ground in keeping with the delicate tones of the trees, Church focuses his interest on their color and form. No number of notes on a pencil drawing could have enabled him to achieve this kind of accuracy or subtlety. As he has left behind few comments on technique, it is impossible to guess whether this study was finished indoors in the studio (as some undoubtedly were) or, as its basic character would suggest, *en plein air*. Though the row of trees is carefully painted over pencil outlines, the hills behind and the sky above were put in relatively quickly, and the lower half of the sheet is unfinished. One might guess that this is the product of a single sitting, perhaps of two or three hours or more. Quite different in spirit and technique, painted on rougher surfaces and, like complete little paintings, with no area left unfinished, are *Campfire: Maine Woods* (no. 5) and *Woodland Stream, Late Autumn* (no. 6). Both date perhaps from the early 1850s, and both are Ruskinian, close-up views in which the artist peers into the earth as William Trost Richards would do in the series of small fern paintings of around 1860. Church was seldom so introspective. There is a sense that these studies were made for their own sakes, not created, as was more usual for Church, to train his eye or hand, to explore a grand subject or to plan a detail or a composition for a painting. *Woodland Stream* is especially compelling. What it lacks in topographical conviction, it more than makes up for in the celebration seen in the cascade of yellow and brown leaves scattered down the banks and across the calm water of a forest stream.

Other woodland studies from the second half of the decade demonstrate a growing control of the medium and an increasingly fine touch. *A Corner of a Pond* (no. 7) is almost finished and rather literal in comparison to *A Great Tree: Deep Woods* (no. 8) or *A Road into the Woods* (no. 9). Both nos. 8 and 9 represent Durand-like views, done at a time when Durand was both the spokesman and the senior figure of the landscape school. These are mainstream subjects, which Church sketched frequently but seldom used in finished paintings. They suggest something about his intellectual and stylistic allegiance to the Hudson River School at a time when he far surpassed the others both technically and in terms of vision and originality.

A Great Tree was surely painted outside, though it could have been finished indoors. His rendering of the huge tree and its rough, mossy bark bespeaks a careful study, perhaps over a long day or even two, for there was no light, atmosphere, or autumn color subject to change. In contrast, *A Road into the Woods* examines late afternoon light as it falls through the woods and onto the side of one tree especially. Here one sees the artist hurrying to rough-in a pencil outline, sketching just enough middle ground to give spatial sense to the scene, then concentrating on the warm light, with touches of pink and yellow, on the straight tree trunk at the right. Shafts of light

fall on the road and on distant trees; the foreground and the three trees to the left are merely blocked in. As a student of color and light, Church has reproduced the effect with haste yet with perfection.

The painter's contemporaries recognized his unique abilities with the oil sketch as much as they admired his dramatic full-scale canvases, as is suggested in the conclusion reached by *The Crayon* in March 1855: "Church is the most remarkable and complete exception to this general fault [not enough acquaintance with nature] of American painters." The writer went on to say, "The direct cause of this poverty . . . is the habit of our artists of making broad sketches without particular reference to detail. . . . The true method of study is to take small portions of scenes, and there to explore perfectly, and with the most insatiable curiosity, every object presented, and to define them with the carefulness of a topographer." The rule followed by Church but by few enough others, was clear: "Young artists should never *sketch* but always *study,* and especially never make studio sketches."[19]

Though the terms are used essentially synonymously today, there is evidence here and elsewhere that Church and his colleagues distinguished between the "sketch," generally in pencil or chalks, in a sketchbook, and the "study," typically in oil on paper or board. Semantic uncertainties abound, of course, and Church poses special problems, as he seldom wrote about his sketching technique in this early period.

Closely related to the woodland scenes are a later series of autumn studies. These also look back to Cole rather than to Durand. The bright foliage had been a major interest of Cole's, the subject of important canvases throughout his career, and the color of fall also became the speciality of Church's contemporary, Jasper F. Cropsey (1823–1900). Church, however, was anything but a painter of fall scenes, for *View near Clarendon, Vermont* is early and modest in scale. It is by far the most successful of a handful of finished autumn pictures.

Yet he continued to do autumn sketches, observing the colors with pleasure and paying tribute, perhaps, to Cole and to the Hudson River School esthetic. Typical in its freshness is *A Maple Tree, Autumn* (no. 10), a study of color rather than of light or form with a correspondingly loose style. Later, in a large sheet dating from 1865 (no. 11), Church painted five separate autumn vignettes, all quick and all close to Cole in color and handling. A second sheet of the same year, *Birch Trees in Autumn* (no. 12), is tighter, more compressed and less reminiscent of Cole.

PLATE 9. Frederic E. Church, GRAND MANAN ISLAND, BAY OF FUNDY, 1852, oil on canvas
(Wadsworth Atheneum, Hartford, Conn.)

Maine and Canada

In 1850, Church paid the first of many summer visits to the Maine coast. Cole had painted at Mount Desert Island years before, and, even more importantly, his trips to Maine may have influenced Fitz Hugh Lane, whose luminous, glowing painting *Twilight on the Kennebec*, had been exhibited at the National Academy in 1849. In 1851, his travels took him still farther, and Church sailed to the barren, rocky island of Grand Manan, Canada, which lies twenty miles offshore of the easternmost point in Maine. When he returned the following summer, he also trekked far inland to sketch Mount Ktaadn (or Katahdin), the highest and most perfectly shaped peak in Maine.

Dating perhaps from the first Maine trip, *The Coast at Mount Desert* (no. 13) is a sketch closely related to *Two Pine Trees* (no. 3). It displays the same intensity of vision, the same reddish-orange ground, and the bottom half of the composition remains unfinished. Here the artist studies the angular forms of Maine's granite coast. The sunlight of a perfect day defines form and shadow, but, as yet, neither light nor atmosphere plays an independent role.

On his Grand Manan trips of 1851 and 1852, Church continued what was essentially a series of geologic studies, examining the rugged cliffs and shoreline of the Canadian island. Though this area is often fog-enshrouded and stormy, the artist apparently sketched only on pure, cloudless days when the sea was calm: the realist carefully selected only those facts that suited his vision. Working now on a somewhat sturdier board, using larger, quicker strokes and a more limited palette than in the Mount Desert sketch, Church created a series of majestic sketches. *Sharp Rocks off Grand Manan* (no. 14) employs bright blues for sea and sky, pure white for the splashing surf and browns for the rocky columns. Even more painstakingly observed is *Cliffs at Grand Manan* (no. 15), a broad view of a sunlit cliff section. Although the brushwork is relatively summary, the whole sheet is worked, and it must again have been the product of a long day (or two) of hard work on the scene. In addition, both sketches relate closely to a finished painting of 1852, *Grand Manan Island, Bay of Fundy* (plate 9). The cliff study (no. 15) could have been used for the tall cliffs at the right in the painting; *Sharp Rocks* (no. 14) suggests the lower rocks in the center. The painting itself is less confidently handled than either *West Rock* and other earlier pictures, or the sketches themselves. The artist confronts the wilderness on his own in these sketches, without apparent self-consciousness. In the painting he introduces a dramatic sunset, in an early attempt at this theme, also paying homage to Lane in the awkward foreground figure and the long rocky shore. These sketches are more advanced; they look forward to his confident and successful handling of the wilderness themes later in the decade.

There is never a clear, consistent pattern relating the sketches to the finished paintings. Far more often than not, rather than sketches with a specific planned painting in mind, Church's works on paper and light board are studies of scenes, objects or light effects that delighted him. For a number of finished pictures from all periods, no studies at all are known; for others (*West Rock* or the *Falls of Tequendama,* for example), there are only pencil drawings; for yet others there are small sketchbook drawings, larger drawings *and* numerous oil sketches *(Niagara; Jamaica).* Much depended on what materials he had at hand. We should remember that, despite the vast number of Church's pencil sketches in the collections of Olana and the Cooper-Hewitt, and the fact that the two institutions own nearly seven hundred oil sketches between them, a great many works on paper may have been lost or discarded in his lifetime or after his death, during the long years when the artist was forgotten.

Though there exist well-resolved sketches for the somewhat confused painting of 1852, *Grand Manan,* there seem to be no preliminary drawings and possibly one oil sketch for the classic painting of *Mount Ktaadn* of 1853 (plate 10). Ktaadn became one of the artist's favorite subjects. It represented the classic eastern American mountain peak, standing alone in the wilderness. Thoreau himself had scaled its crest and praised it, and for Church it had all the elements of a worthy subject. In the mid-1870s, the artist bought some land on Lake Millinocket, within sight of the mountain, where he built a camp. Yet the only apparent sketch prior to the painting is one entitled *Mount Katahdin from Lake Katahdin* (no. 17), which is undetailed, atmospheric and difficult to imagine as the only study for the carefully conceived painting. This sketch is an early twilight study in which Church has captured the evanescent effects of the color and reflection of the setting sun, seemingly his central concerns, by brushing the surface very rapidly. (Later on, when he knew the scene well, he would sketch mountain and lake again and again, as if running his hands over a treasured object [*see* no. 18].) Much the same is true of a larger sketch, *Eagle Lake Viewed from Cadillac Mountain* (no. 19), also from the mid-1850s, executed high on Mount Desert. Again, we see the artist speeding his technique, using a painterly shorthand so that he could record light effects and view. In these two works (nos. 17 and 19), he records sunlight and sky and instinctively begins working toward the Constable-like manner he would develop in the following decade.

During the 1850s Church returned frequently to the Maine coast, often sketching the surf and waves. From the beginning of his career, when he painted *Lower Falls, Rochester* (1849), the motion and power of water had fascinated him. At Niagara he learned how to paint water convincingly. Though his rendition of the great falls surpassed all others in accuracy and directness, he always remained cognizant of the subject as American icon. Perhaps the ocean continued to appeal to him as neutral, as representing nature in her purest form without any association of time or place.

Sketches such as *Stormy Sea* (no. 20) may be what the *Cosmopolitan Art Journal* was referring to in September 1860, when it reported that Church was planning a major iceberg picture. The artist had been to Labrador in 1859 and then had gone "to the coast of Maine to make the necessary water studies."[20] Though most of the studies of the coast concentrate on the boiling waves

PLATE 10. Frederic E. Church, MOUNT KTAADN, 1853, oil on canvas (Yale University Art Gallery, Stanley B. Resor, B.A. 1901 Fund)

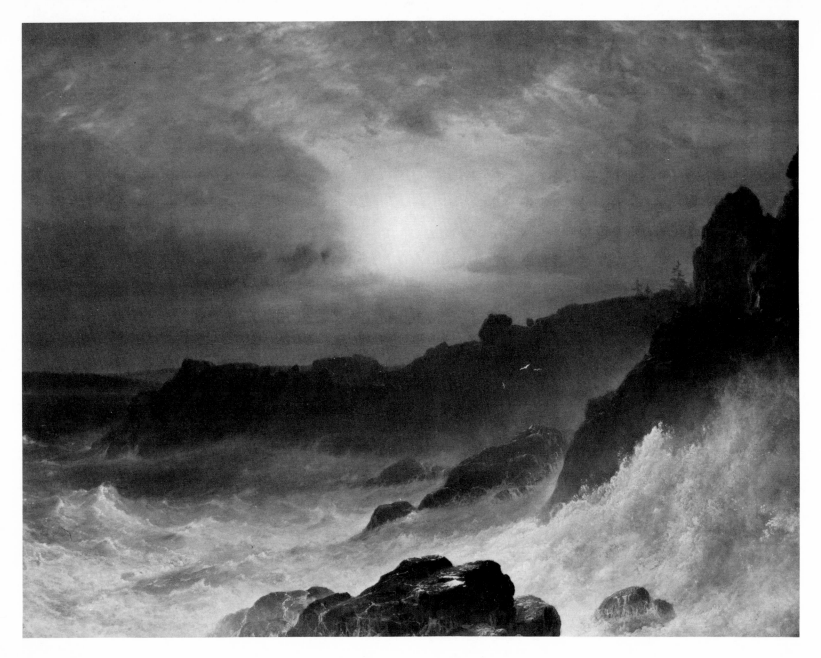

PLATE 11. Frederic E. Church, Sunrise off the Maine Coast, 1863, oil on canvas (Wadsworth Atheneum, Hartford, Conn.)

themselves (*see* nos. 21–23), like Winslow Homer twenty years later, Church painted the harsh coast as an empty, unspoiled American wilderness. *Maine Surf* (no. 22), particularly, prefigures Homer's compositions. Though Church's handling never takes on the symbolic and decorative qualities of Homer's paint, in his efforts to *re-create* the actual appearance of things, Church's compositions always retain their descriptive interest.

One of the last of these studies, *Sketch for "Sunrise off the Maine Coast"* (no. 23) is the great rarity in Church's *oeuvre*. It is the *plein air* sketch that became a finished oil (*see* plate 11), almost without change. In the *Sketch* the artist looks across at surf and rocks, with the spray crashing up on the right, almost at his feet. In the painting of 1863, the form of the cliff in the middle ground is followed almost exactly, as are the waves. Drawing on other sketches and other experiences, Church makes the central foreground rock smaller, bringing the viewer even closer to the water, and he raises the horizon considerably, adding a spectacular pink and yellow effect of sunlight through mist. Rather than sitting down as Cole would have done with the initial conception of a finished painting in mind, Church very likely executed the study objectively, to record the rocks and water. His sketches were experiments through which he taught himself the lessons of art and nature. Presumably, it was only later that he saw the full potential of this one.

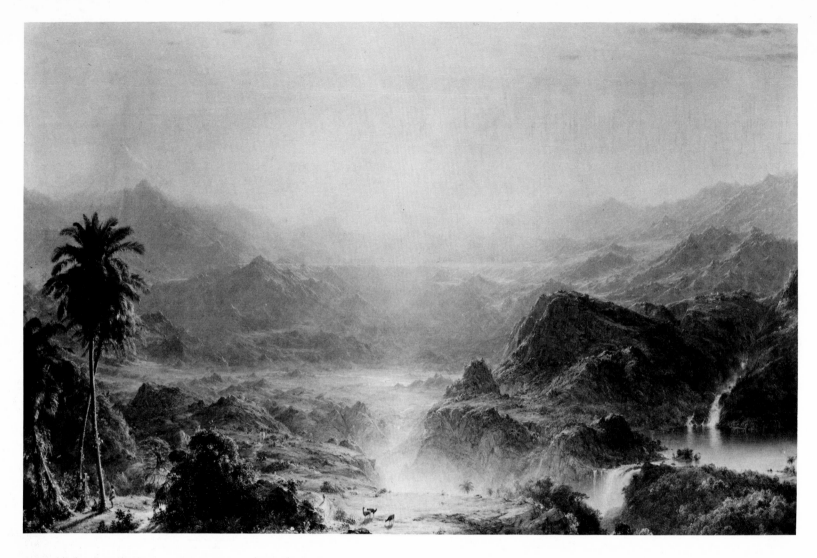

PLATE 12. Frederic E. Church, THE ANDES OF ECUADOR, 1855, oil on canvas (Reynolda House, Winston-Salem, N.C.)

South America

As David Huntington has made clear, Church was, in effect, the landscape painter for whom Alexander von Humboldt, the influential German naturalist, had prayed. In the *Cosmos* (1849) and in his *Views of Nature* (1850), Humboldt urged painters to examine "the humid valleys of the tropical world," observing, as if he had had Church in mind, "It would be an undertaking worthy of a great artist to study the character of all these vegetable groups, not in hot houses or from the descriptions of botanists, but on the grand theatre of tropical nature."[21]

Humboldt did not stop with this general advice: "Coloured sketches, taken directly from nature, are the only means by which the artist, on his return, may reproduce the character of distant regions in the more elaborately finished pictures; and this object will be the more fully attained where the painter has, at the same time, drawn or painted directly from nature a large number of separate studies of the foliage of trees: of leafy, flowery, or fruit-bearing stems; of prostrate trunks. . . ."[22]

Humboldt accurately predicted the approach of his American disciple, especially as seen in Church's many surviving Jamaican sketches from the trip of 1865. But, surprisingly, there are few detailed, naturalistic oil studies from the artist's two South American trips of 1853 and 1857. It is well-known that the paintings resulting from those early trips, such as *The Andes of Ecuador,* 1855 (plate 12) and *The Heart of the Andes,* 1859 (The Metropolitan Museum of Art), were admired then, as now, for the extraordinary detail with which the jungle foliage, vines, flowers, mosses and rocks are depicted.

It is true that Church in the mid-1850s was just beginning to realize the potential of the oil sketch. Still, even by 1853, his abilities in that medium were considerable, and the fact that only a handful of studies survives from the first trip, and that they are in poor condition, suggest that many of the early South American sketches have been lost. Typical is *Colombian Waterfall* (no. 24), which recalls the upper falls to the right in *The Andes of Ecuador.* Executed on heavy paperboard coated with a light beige ground, it was badly torn and frayed before recent restoration. It is far more hastily and broadly sketched than the Jamaican studies, or even than those from 1857, and the work suggests both the wonder and the physical discomfort that Church must have felt during this rugged venture by boat and on foot through nearly impossible terrain. More carefully executed is the study of a boy, *Justiniano de la Rosa* (no. 25), which Church made a month earlier in early May while still at the entry port of Baranquilla, Colombia. The artist apparently had time to make a careful likeness, a rare example of portraiture in his *oeuvre.*

Despite the surprising paucity of their number, their concentration on the mountain peaks and the seemingly scant attention to the rich tropical flora, the studies from the 1857 trip are magnificent. One of Church's favorite subjects was Cotopaxi, the greatest volcano of the Andes, perfectly symmetrical, picturesque, breathing fire. In June 1857, the artist did numerous sketches from all angles, in pencil and in oil. Surely on this occasion he was already planning a great painting, working for the first time as a fully equipped artist-naturalist. *Cotopaxi from Ambato, Ecuador* (no. 26) shows an early view of the peak, with a long mountain range to the right. *Study of Cotopaxi Erupting* (no. 27) pictures the vaporous explosion shooting up into the sky, much as in the final painting (plate 13). In the former, Church is still consumed with the conical shape of the snow-covered peak; in the latter, he has mastered that problem and can concentrate on the exact appearance of the smoke as it rises and is carried out across the land.

Mount Chimborazo, which Church visited in June of 1857, posed a similar though less complex problem. Though the artist always portrayed the dramatic, rounded profile of the snow-capped peak, he examined the cap from various distances and under different conditions of weather and atmosphere. The problem was one of scale: How could he express on canvas something of the wondrous immensity of the mountain? One solution was to show a village and other mountain ranges in front of Chimborazo (no. 28); another was to paint it with dense mist surrounding it, only the white peak clearly visible (no. 29); on a third sheet (no. 30), the artist experiments compositionally, using every inch of the valuable surface; in the final view (no. 31), the mountain looms high above its neighbors, with the lower mountains and the foreground sketched in, quickly and confidently. These pictures were admired by Church's contemporaries, and his trips were chronicled with great interest. Even while he was traveling, one magazine reported that he was "in South America, making studies of the magnificent scenery of . . . that almost unknown region"; on his return *The Crayon* reported, "Mr. Church has in his room a number of very pleasing studies, the result of his late trip to South America."[23] Yet however much *Mount Chimborazo* (no. 31) might have been admired, its lack of finish made it only a "study," presentable neither for public exhibition nor for sale. Indeed, there is no record that the artist ever sold or even gave away any of his remarkable "studies."

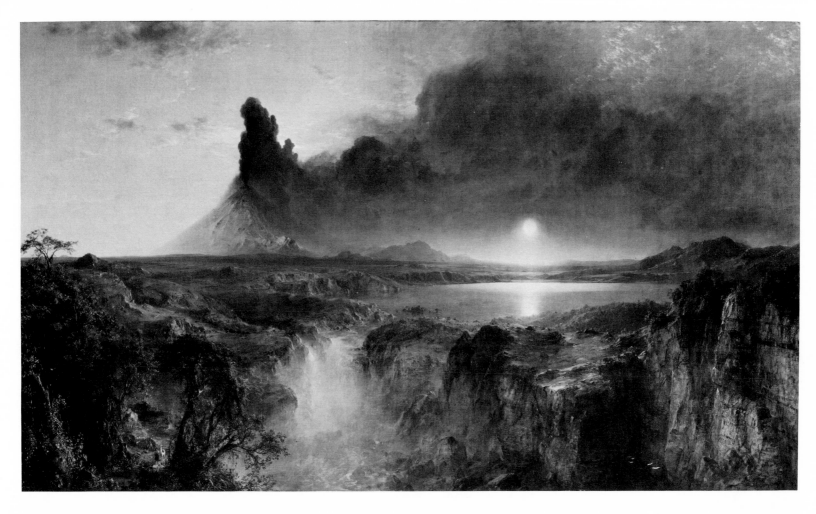

PLATE 13. Frederic E. Church, COTOPAXI, 1862, oil on canvas (Detroit Institute of Arts)

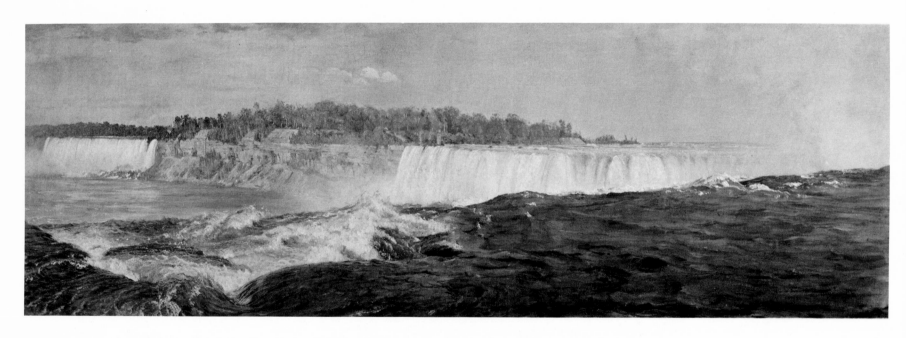

PLATE 14. Frederic E. Church, STUDY FOR "NIAGARA," 1857, oil on canvas (Collection of Hon. H. John Heinz III)

Niagara

Niagara, like Cotopaxi, presented an impossible subject, paradoxically, not because it was remote and un-painted like the volcano, but rather because it *was* accessible, oft-painted and iconic. Church approached it as he had Cotopaxi, probing it with pencil and brush from every angle, in varying seasons, sometimes above it and at other times standing almost under its deafening, wet spray. When he first stood at the falls in March 1856, he saw it surrounded by snow and filled with breaking ice, and he painted one of the most brilliant of all his sketches, *Niagara from Goat Island, Winter* (no. 32; cover illustration). Standing on Goat Island, looking down at the barely visible Horseshoe, he painted mist rising to meet low clouds from a passing storm and bathed them both in the coral-colored light of late afternoon. The sketch is rich and complete, sensuous in color and execution. With this study, as with others, one wonders whether it was executed *en plein air* or at least partially indoors. The composition was based on two pencil studies of March 20 (both now at the Cooper-Hewitt). One might guess that the artist made a pencil outline of the basic forms of topography and tower in his quarters before taking the sheet outdoors, where he sketched the colors of snow, water and sunset. A study this complete might then be brought back to his room or studio for finishing touches, though here the result is so fresh that there appear to be no afterthoughts.

The artist must have been drawn to the falls, for he returned in July and again in the autumn, presumably making numerous studies each time. On one occasion he sketched the falls from the shore (*see* no. 33) in a traditional composition not unlike those of John Trumbull and Alvan Fisher much earlier in the century. Another time, he looked back up the river and studied the swirls and eddies of the water as it approached the falls (no. 34). His sketches struggle with this immense physical and artistic problem. It is hard to know when he first began to approach the falls as a horizontal panorama seen from the Canadian side. This is the solution first found in an oil study (plate 14), which may be the work referred to in a *Crayon* column of February 1857:

> "*Mr. Church, as one of the results of his summer studies, exhibits a sketch of Niagara Falls, which more fully renders the 'might and majesty' of this difficult subject than we ever remember to have seen. . . . The point of view is happily chosen . . .; the eye is not diverted . . . from the soul of the scene by diffuse representation of surrounding features.*"[24]

Church did just this, eliminating all of the usual foreground, or *repoussoir* elements. The sketch portrays the whole falls—the American side on the left and the Canadian on the right. In the final painting (plate 15), noted by another *Crayon* piece in May as having been "reproduced

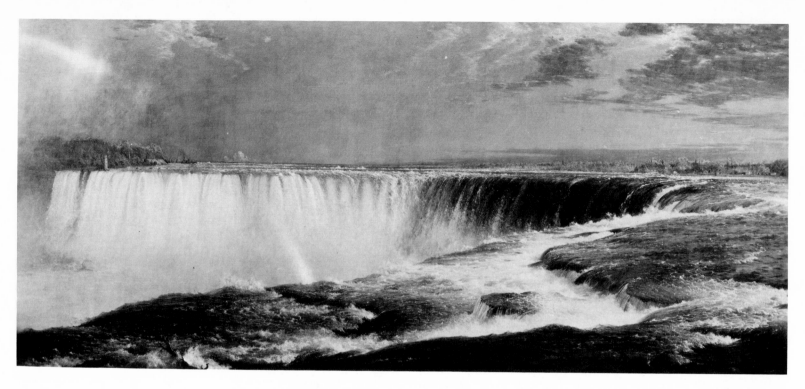

PLATE 15.
Frederic E. Church, NIAGARA, 1857, oil
on canvas (Corcoran Gallery of Art,
Washington, D.C.)

from the sketch previously noticed in our column,"[25] he cuts off the American falls completely and concentrates on the Horseshoe, drawing the viewer even closer to the water.

When it was exhibited in New York, Church's *Niagara* was hailed as "incontestably the finest oil-picture ever painted on this side of the Atlantic,"[26] and Ruskin is reported to have particularly admired its effects of light on water at its London debut.[27] The painting established Church's reputation, and it is not surprising that he returned to the theme. In retrospect, one might in fact wonder why he didn't go on to paint as many Niagaras as he did Cotopaxis (of which there were at least five finished versions). In any case, a painting entitled *Under Niagara* (now lost) was done in 1862, and another large picture, *Niagara Falls from the American Side* (plate 16) was executed in 1867 and entered the A. T. Stewart Collection.[28] Inspiration for the *American Side* may have come from the photograph, now at the Cooper-Hewitt, on which Church has sketched lightly in oil, building up form and emphasizing color and mist (*see* no. 35). The artist as scientist now feels completely comfortable with the newly emerging photographic medium.

Church may also have visited the falls again in preparation for *Niagara Falls from the American Side*. A Boston dealer's brochure explains, perhaps apocryphally, how the artist had climbed a tree and cut away foliage in order to make his sketch.[29] However, there are oil sketches such as *At the Base of the Falls* (no. 36) that are somehow so quickly and broadly painted, and have such a new vertical thrust, that they appear to be products of this later interest in the falls.

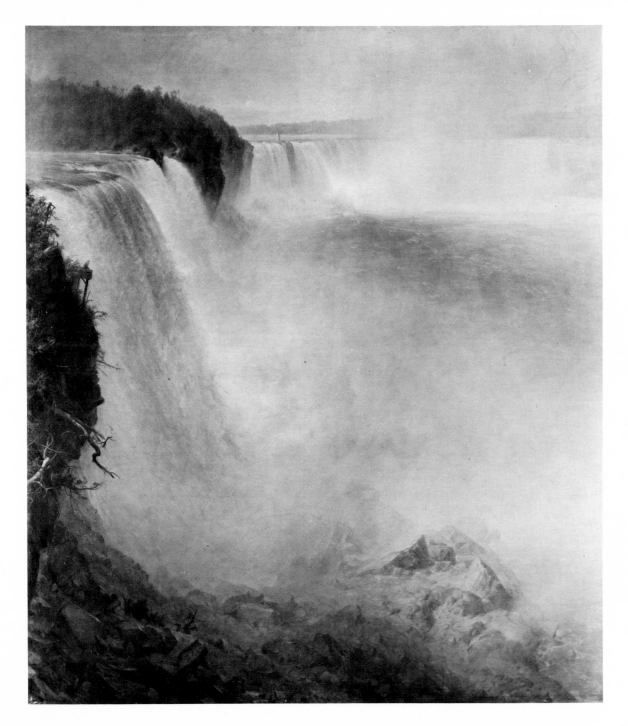

PLATE 16.
Frederic E. Church, NIAGARA FALLS
FROM THE AMERICAN SIDE, 1862, oil
on canvas (National Galleries of
Scotland)

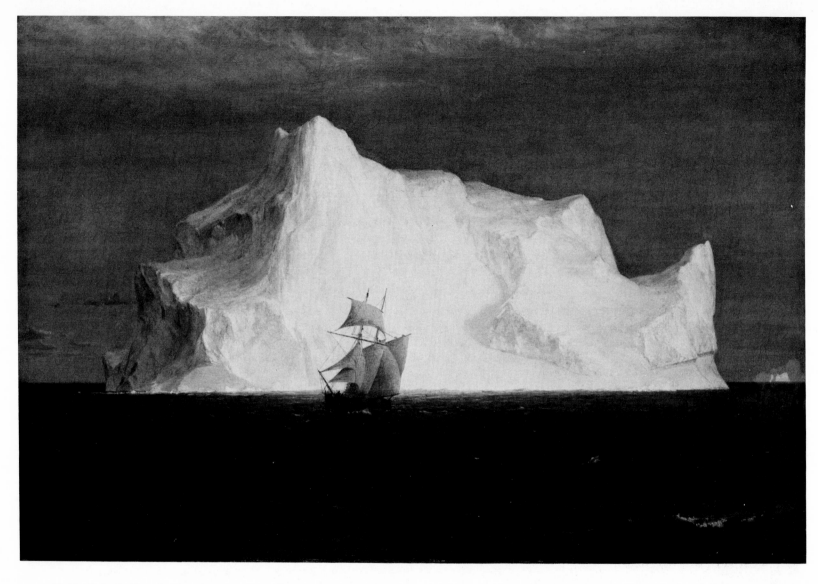

PLATE 17. Frederic E. Church, THE ICEBERG, 1891, oil on canvas (Museum of Art, Carnegie Institute, Pittsburgh, Pa.)

The North

In 1859 Church determined to go North to paint icebergs. As exotic, distant and difficult as the tropics, the North was another ideal subject for him, and icebergs were just becoming the subject of popular interest.[30] With many travels and great achievements behind him, Church planned the expedition carefully, talking "with scores of arctic voyagers,"[31] and reading their journals and books. According to Tuckerman, who knew him well, he then "drew, from oral description, the most characteristic forms, and acquired a definite notion of the tints which belong to the icebergs. . . ."[32] So Church's first oil sketches of the subject were probably made well before he had seen them. *Iceberg Fantasy* (no. 37) is just this kind of preliminary color study. With the icebergs, as with the tropical subjects, the Near East and others, the artist carefully prepared himself so that he would know what to paint and how to paint it when he arrived. Using books such as *Cosmos,* earlier, or Elisha Kent Kane's *Arctic Explorations* (1857), as well as lithographs, engravings, verbal descriptions, guidebooks, natural history and photographs, he became thoroughly aquainted with his subjects. He knew what he was looking for, what he wanted to see, and thus he could make the most of limited time sketching the scene.

Fortunately, Church was accompanied on this Northern trip by Rev. Louis L. Noble, who recorded their adventures and gave a good account of the artist's working habits in his book, *After Icebergs with a Painter* (1861). The two men embarked on June 19 on a steamer bound from Halifax and then to Saint John's, the primary port on Newfoundland. They spent about two days there sightseeing and procuring a sixty-five ton schooner, the *Integrity,* "at Church's sole expense, and under his control."[33] The *Integrity* started North on June 30, and for nearly three weeks they sailed, traveling up the eastern coast of Newfoundland, then through the Straights of Belle Isle on their way south to Sydney, Nova Scotia.

Church sketched the schooner and a steamer, possibly the one he had sailed on, with considerable care (no. 38), using a limited palette on a light beige ground. Then in another small sketch, using the same grays but now with quick, long strokes, he recorded his wonder at seeing icebergs in the distance, perhaps for the first time (no. 39).

Noble records the moment when they first came close enough to paint one in more detail: "We gazed some minutes with silent delight on the splendid and impressive object, and then hastened down to the boat, and pulled away with all speed to reach it, if possible, before the fog should cover it up again . . . C[hurch] quietly arranged his painting apparatus." When the fog lifted again, the artist began: "For half an hour, pausing occasionally for passing blocks of fog, he

plied the brush with a rapidity not usual, and under disadvantages that would have mastered a less experienced hand. . . ."[34] Presumably in this time he could finish a quick sketch such as *Iceberg, Newfoundland* (no. 40). (Other sketches, such as the skies, might have required even less time, as suggested by Bierstadt's reportedly having said on one occasion, "I must get a study in colors; it will take me fifteen minutes!")[35]

Typically, as they came to see more and more icebergs, the artist and sailors in the rowboat would pursue the more interesting one as the men tried to hold the boat as steady as they could while the artist worked. But the constant motion of the sea must have made things difficult. Added to this, Church was apparently constantly seasick and suffered accordingly. These are *sketches* indeed, quickly made, exploring the nuances of shape and mass, of color and reflection, of storm and sunset. With only one exception (no. 47), none are executed in any detail, and none bear the sense of perfect resolution that one finds elsewhere in the studies of trees, seashore or jungle foliage. Nonetheless, they form an impressive and unique group, and they vary considerably among themselves. In some, he is curious about the form of the great islands of ice, and, conserving his supply of paperboard, the artist studied these forms on long, horizontal sheets (*see* nos. 41, 42 and 43). In the latter, *Two Icebergs,* one sees a third, conical berg outlined in pencil but left unfinished. In other sketches, effects of storm and light become the central interest, and the shape of the iceberg is only hastily considered. In *Iceberg, St. Lewis Bay, Newfoundland* (no. 44), an almost turquoise iceberg is seen against a dark mauve, stormy sky. The artist then reverts, in the most rapidly brushed of these sketches, to an early and constant interest in dramatic light. *Iceberg against Evening Sky* (no. 46) is a study of an orange sky and light green water. *Icebergs at Midnight, Labrador* (no. 47) depicts a bright red sky and blue iceberg and is the broadest coloristic impression. No attempt is made to describe detail; he simply records the eerie light.

At the opposite end of the scale is the careful study, *Massive Iceberg* (no. 48), in which the strong sunlight reflects off the irregular surface of a monumental white berg on a dark sea. There is no evidence that the artist rushed; he seems to have engaged in a leisurely and careful study, perhaps one done from the safety of shore during their stopover at Battle Harbor, Newfoundland. The iceberg itself recalls the reaction of Winthrop and Church as they saw their first iceberg: "There, about two miles distant, stood revealed the iceberg in all its cold and solitary glory. It was of a greenish white and of the Greek-temple form, seeming to be over a hundred feet high."[36] Moreover, in terms of composition and color, this iceberg is more like the one that appears in a painting of thirty-two years later, wherein a small schooner (perhaps the *Integrity*) sails in front of a dramatic white iceberg (*see* plate 17).

Few finished paintings resulted from this arduous Northern adventure, and only one of major size and ambition: *The Icebergs* (or *The North*) of 1861, now lost, and known only through a chromolithograph (plate 18). Its composition and coloring both seem confused, particularly considering that these were Church's best years; it was during this period that he painted *Twilight in the Wilderness* (1860), and *Cotopaxi* (1862). Interestingly, the oil sketch (no. 49) closest to

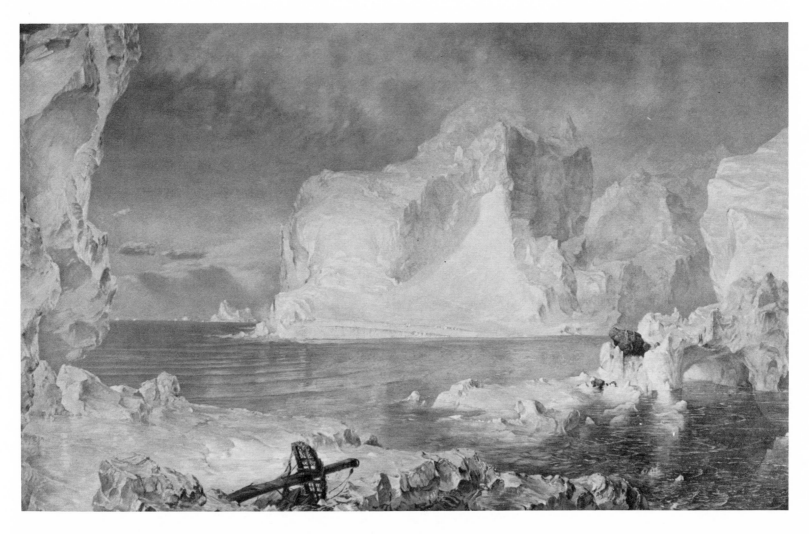

PLATE 18. After Frederic E. Church, THE ICEBERGS (THE NORTH), 1861, chromolithograph (Olana Collection)

the painting is one of the very imaginary ones which looks almost as if it might have been conceived before the trip itself. The painting may reflect Church's physical and artistic discomfort with this subject, perhaps bearing out Tuckerman's suggestions that the endeavor was artistically "a hazardous experiment."[37] Nonetheless, the painting drew as much critical praise as any of his much-admired works, and the London critics particularly gave it "unqualified approval."[38]

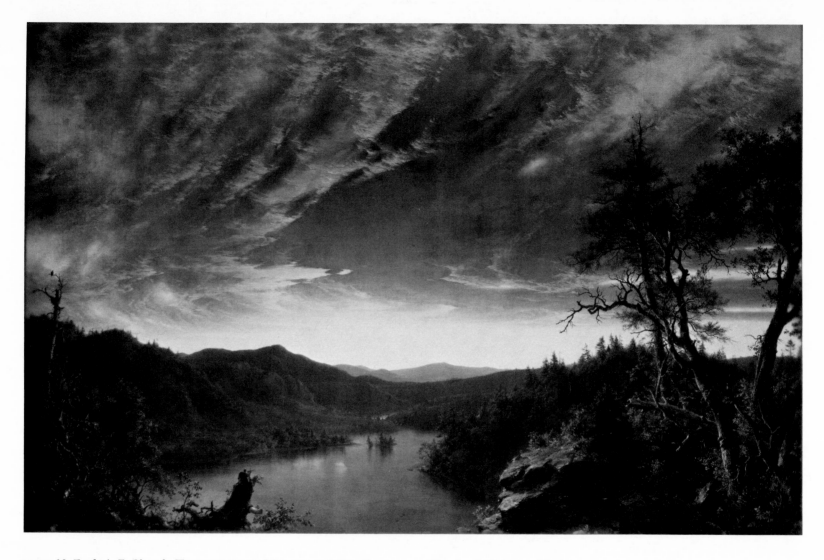

PLATE 19. Frederic E. Church, Twilight in the Wilderness, 1860, oil on canvas (Cleveland Museum of Art)

Jamaica

I n March of 1865 Church's two-year-old son and his infant daughter died of diphtheria within a few days of one another. In April he went to Jamaica with the artist Horace W. Robbins (1842–1904) and there engaged in what Huntington has accurately called a "frenzy of pencil and oil sketching."[39] From personal tragedy seems to have come artistic passion, for his greatest series of oil studies was produced during this four-month visit. His contemporaries took immediate note. Tuckerman wrote of this group of sketches: "There are admirable effects of sunset, storm, and mist . . .; the mountain shapes, gorges, plateaus, lines of coast, and outlines of hills: beside these general features, there are minute and elaborate studies of vegetation—all the materials of a tropical insular landscape, with every local trait carefully noted."[40]

Church's Jamaican sketches echo, in the preparatory medium, his accomplishment in the great North American wilderness paintings, from *Mount Ktaadn,* 1853, to *Twilight in the Wilderness,* 1860 (plate 19). As we have seen, few oil studies exist for these North American pictures. At a time when the Civil War was ending and when the optimistic, realistic style of mid-century was wavering, the detail and range of the Jamaican work suggest that here he returned, for the last time, to the esthetic of Ruskin and Humboldt. If Church's oil sketches of the early 1850s had been somehow in advance of his finished work, the Jamaican ones were on the verge of being *retardataire,* for the artist was no longer able to carry out their demands or their promise in a large exhibition picture. The two major Jamaican oils that resulted were *Rainy Season in the Tropics,* 1866 (The Fine Arts Museums of San Francisco), which succumbed to generalized effects of emotion and light, and *The Vale of Saint Thomas, Jamaica,* 1867 (plate 20). *The Vale of Saint Thomas* was a final not unsuccessful attempt to bring a heroic, Adamic vision to a broad tropical panorama, yet it could not live up to *The Heart of the Andes* or *Cotopaxi.*

These sketches reveal a tremendous range of technique, scale and subject matter. Many are involved with the closest examination of nature. They are botanical studies taken close-up, with the methodical eye of a naturalist and the explorer's sense of wonder. Relatively broadly brushed are the wonderful *Penguin Plant* (no. 50) and the *Century Plant* (no. 51), a great thorny bush studied in greens. *Philodendron Vines, Jamaica* (no. 52) is dark, intensely observed, and *Jamaican Flowers* (no. 53) is a wondrous celebration of the richly colored flora of the island. It is difficult to imagine anyone but Church needing or making these studies. Here is the pure joy of the artist in Eden. The sketches are botanically accurate and personally expressive. They may be seen as perfect examples of the new mode of Ruskinian, "growing" still life, where fruit and flowers are

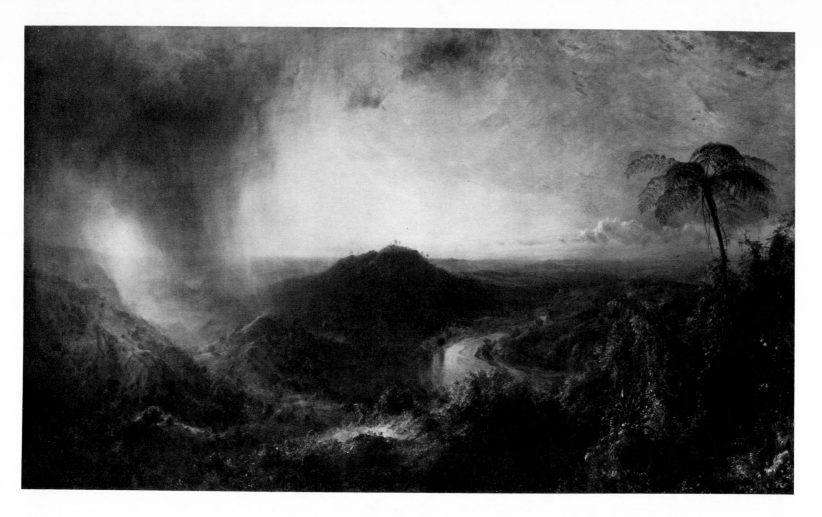

PLATE 20.
Frederic E. Church, THE VALE OF SAINT
THOMAS, JAMAICA, 1867, oil on canvas
(Wadsworth Atheneum, Hartford,
Conn.)

36

shown in their natural, living form by men such as W. T. Richards, George Lambdin, William and John Hill and, of course, Church's friend, M. J. Heade.

In other cases, Church stepped back to observe some of the larger jungle forms. Again he did so with incredible fastidiousness. His aim was to record the form of an individual species. The skies are gray, and there is little evidence of changing light. *Wild Philodendron on a Tree Trunk* (no. 55) takes an earlier subject (*see* no. 52) and displays it organically in complex, lacy patterns. Detailed, time-consuming sketches like this one and *Tropical Vines* (no. 56) have been rightly compared to photographs, and Church is known to have collected rather similar photos by Samuel Bourne and others. However, at this date, the vision and technical abilities of the painter were more advanced than those of the photographer. The photos that Church owned and that look so similar to his paintings (*see* plate 21) actually date from some two decades later.[41]

The artist's technique had to be adaptable to the need for speed, the vicissitudes of weather, the time of day and, most importantly, to his purpose, or how the object or scene affected him. *Palm Trees* (no. 57) is a careful study in which both foliage and the quality of light from a clear blue sky are considered. *Deep Jungle Foliage* (no. 58) is quicker, with high detail only in the left center, on the tree that attracted his attention. Quite different is *Rain Forest, Jamaica* (no. 59), inscribed by the artist "Rain forest up in Blue Mts—about 5,500 feet up," for it is a superbly emotional study of form and light, executed quickly with heavy, wet strokes. To create it, the artist and his companions must have had an arduous climb, and they doubtless faced a long trek home the same day. The precision possible in studying an object at length, perhaps within a few steps of shelter, was simply out of the question.

The artist also made extensive studies of the topography of the island, paying particular attention to the hillsides and mountains and the sunlight and storms that came over them. Sometimes these were quick vignettes (*see* nos. 61 and 62) taken from the trail, requiring no more than fifteen or twenty minutes. On other occasions, Church used larger sheets to record the shape and color of the mountains and atmospheric effects, viewed from higher altitudes. Topography is the major concern in *Mountains in Jamaica* (no. 63). *Storm in the Mountains* (no. 64) treats the hills summarily though lavishes considerable care on the horizontal band of thunderclouds overhead and the white clouds under bright sunlight in the distance.

Church's Jamaican sketches are frequently inscribed "Jamaica" and sometimes bear the month and year as well; a few date from May and many from June, July and August 1865. There is no apparent progression of interest or style, though, as one might expect, the most mature panoramic views are likely to date from the last two months. The dates and occasional notes appearing on the versos were exclusively for the artist's later reference. Because there was no reason to do so unless he was particularly pleased with something or expected to finish it sufficiently to sell later on, only rarely did he sign an oil study. *Red Hills near Kingston* (no. 65), for example, *is* signed and dated. Though not as highly detailed as some, it is nearly "finished" in the mid–nineteenth-century sense. The foliage and flowers form a distinct foreground, there is a middle-ground of cultivated valleys, the well-formed mountains are seen in the distance, and a dramatic storm appears above. All it lacks is a point of interest, usually a human reference such as a village in the valley or a peasant near the foreground.

Among the most beautiful of all these sketches are two large ones in which the artist, positioned at a high point and looking out over miles and miles of tropical wilderness, examines the Blue Mountains as they fold over, one against another, in bright sunlight (*see* nos. 66 and 67). Now near the end of his stay, the painter must have been planning a great Jamaican painting, and indeed both of these sketches recall the high point of view and the composition of *The Vale of Saint Thomas, Jamaica.*

Church also worked on Jamaican light and atmosphere in a series of studies in which he extended his range in the sketch medium farther than ever before. In this series, he was able to paint the sky almost alone. Working constantly from a high vantage point, less fearful of the majestic tropical landscape than he had been a decade earlier, he has created small sketches that are among his boldest. *The Sea from a High Bluff* (no. 68) recalls his first iceberg study (no. 37) in its simplicity; color is quickly brushed in over still-visible pencil strokes. *Palisades near Kingston* (no. 69) bears the same kind of directness and portrays his interest in the long tidal coastline that stretched for miles beneath his feet. In the boldest of the island sketches, Church raised his eyes from the land to sketch its dramatic light effects. *Thunderheads, Jamaica* (no. 70) depicts great storms clouds building up at midday. *Cloud Study, Jamaica* (no. 71), *Orange Sunset* (no. 72) and *Sunset, Jamaica* (no. 73) all include minimal reference to mountains in the foreground, defining place and scale, capturing the quickly changing yellows, oranges and pinks of a tropical twilight. These were surely made as quickly as the artist could manage—the effects are literally those of an instant. Having roughly sketched in the dark hills below with a broad brush, Church must have waited for the clouds to reveal the particularly pleasurable, fleeting light he sought, and he used rich impastos to sketch it. Interestingly, these Jamaican sunsets are warmer than those he had painted previously. The colors are more pastel-like than those in the finished Jamaica pictures themselves, in which he resorted to cooler, more traditional tones. Like his other Jamaica sketches, these were particularly successful. In the end, the island may have lacked the single great peak or high falls that could have given focus to a single heroic landscape, but it may be that Church's great Jamaican painting lies in the sketches themselves.

Europe

A few months after finishing *The Vale of Saint Thomas, Jamaica,* Church departed for Europe in the autumn of 1867 on the most extensive journey of his career. It was his first trip to that continent, and he traveled for over a year and a half, visting Paris and London briefly, and then on an extensive tour to the Near East, to Constantinople, Vienna, Switzerland, Rome, Pompeii, Greece and finally back to London and home. Church had always avoided the Old World, perhaps from an instinctive fear of what he once called "baleful foreign influences." On his trip he spent as little time as possible in the great capital cities and sketched them but rarely. He rejected what he saw there (Rome, the home and the inspiration of so many of his painter predecessors, he pronounced "cheap and vulgar"). On the long trips to "purer" places, particularly, Egypt, Greece and the Alps, he sketched more frequently, at times with superb results. Yet a distinct change comes over his art on this trip. His vision somehow becomes less original, the views he takes are more conventional, and one feels little of the frenzy of emotion and close observation that had typified his work from the late 1840s to the Jamaican trip of 1865.

The facts that Church found himself recording now were ancient ones. The painter of the New Eden rushed headlong from place to place in the Old World, and if he was sometimes moved, more often he must have felt puzzled as he pressed on through the arid, unfamiliar land. Seeking rejuvenation, he found the heroic, Transcendentalist style becoming irrelevant in light of changes at home and in relation to the Ancient World itself. The explorer-artist had become the tourist.

Church was fascinated by the people he saw, the villages, the local customs and languages, as well as by the landscape and architecture, and he kept busy sketching (*see* nos. 74, 75 and 76). The camel interested him particularly. He drew it often in his sketchbook and made numerous oil studies as well. Despite the pace and the difficulty of travel, these sketches are unhurried and certain, precise and colorful.

Departing Jerusalem for the ancient city of Petra (just north of Aqaba in what is now Jordan), the artist and a considerable party of retainers passed through a valley "called Yemen." In his journal he recorded the pleasure of seeing "one of the most stupendous views I have ever had the delight of witnessing . . . we gazed down into a tremendous valley narrow but deep, at the bottom of which lay the silvery white bed of . . . torrents. . . . Gigantic mountains rose sublimely from the gorge."[42] The artist records flinging open his "pocket sketchbook," "sketching and running," then setting up camp to facilitate more careful views. Clearly, he felt again the surge of

enormous energy and excitement that a great sight had always triggered in him. But the best of the oil sketches that resulted (no. 77) remains unconvincing in comparison to the Jamaican panoramas. The scene is recorded accurately, no doubt, but the feeling for real space, distance and light is gone.

Reaching Petra, the artist immediately sought out the tomb of El Khazneh, cut from the rock walls of a "beautiful rich reddish salmon color"; he wrote "I never saw anything so gorgeous." They remained at the site only two and a half days, and the artist reported: "I made a few rough oil sketches and some hurried pencil studies but I have got the thing in my head pretty clear."[43] The oil sketches he produced in fact are quite specific (see no. 78) in terms of form and color, though implied in Church's statement is his desire to spend more time making precise studies, his semantic nondistinction between "study" and "sketch," and, as was well-known, his reliance as nearly as much on a superb visual memory as on sketches and other aids. As his student William Stillman reported, Church's "retention of the minutest details of the generic or specific characteristic of tree, rock, or cloud was unsurpassed by the work of any landscape painter . . ., and everything he knew he rendered with a rapidity and precision which were simply inconceivable by one who had not seem him at work."[44]

In March, the artist and his party, including his wife, were back in Jerusalem, at which time he made several oil sketches of the city from the Mount of Olives (nos. 79 and 80). Both have quickly sketched foregrounds but they must have been time-consuming, as each records, with great care, the architecture of the Holy City. Shortly after his return, Church painted a large view of *Jerusalem from the Mount of Olives*, 1870 (William Rockhill Nelson Gallery and Atkins Museum of Fine Arts, Kansas City), the major picture of the long trip. Church had recovered from an initial feeling of disappointment at seeing Jerusalem, and the sketches are fine ones. They are unlaborious yet accurate, with a strong rendition of the bright sunlight glinting off the buildings of the ancient city.

Church's journals make it clear that he was interested in photography by this time. It must have fascinated him to see that the photograph could record some of the facts he had been taking down with such care in oil and pencil sketches. There is no evidence that he ever used a camera himself. His journal makes several references to the new science. He notes that on leaving for Baalbek, the party "was accompanied by a photographer," and later at the Acropolis he writes, "No photograph can convey even a faint impression of its majesty and beauty."[45] At this time, photographs must have helped him find the ruins and sites he wanted to see, as lithographs and guidebooks had earlier. There are some instances in which photos in his own collection portray the same subject as one of his oil sketches (see no. 81 and plate 22), but even in this case, increased wear on the rocks in the photo suggests that it probably antedates Church's sketch.

After sketching the ruins at Baalbek (in present-day Lebanon), the party proceeded to Beirut, sailing there for Cyprus and Rhodes. On the way the artist sketched the snow-covered peaks he called "Mt. Lebanon" (no. 82). The landscape was an eerie one, somehow without sharp focus or

detail, and the sketch succeeds in suggesting the aridness of the land and the drama of distant mountains.

The long journey to Constantinople and then up the Danube to Vienna yielded few sketches, but in late June he was in Berchtesgaden, Bavaria, and for two months he was busy traveling and sketching in the lower Alps. He produced one effective loose sketch of a thunderstorm in a mountain valley, with a long lightning bolt crackling down, and a rainbow to the right (no. 83), but even this return to atmospheric interests is somehow contrived and more obvious than before. More typical is the fine unfinished study of *The Watzmann and the Hochkalter near Berchtesgaden, Bavaria* (no. 84), in which the topography and trees are outlined, a village is pencilled into the foreground, and mountains and sky are finished in detail. Surely the Alps reminded him of the great tropical peaks, and Church's technique reverts momentarily to an earlier manner. Here and in the large and very handsome *Alpine Valley* (no. 85), rock formations are, with the old vision, handled with loving detail. The light effects seem natural and unforced, and large parts of the foreground are left unfinished as the artist's concentration increases. In its convincing color

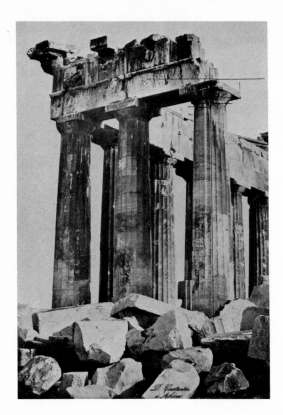

PLATE 23.
D. Constantin, RUINS AT ATHENS, photograph, n.d. (Olana Collection)

and minute detail, *Alpine Valley* reminds us of the *Cliffs at Grand Manan,* some sixteen years before.

This quality of fresh observation and believability is sustained even when the artist confronts such traditional Old World subjects as Salzburg, Austria. A view of the castle (no. 86) is fine and fresh, combining broad brushwork in hills and foreground with a tight handling of the old architecture. Closely related is the horizontal *View of Salzburg* (no. 87), which also makes use of pastel-like hues on a beige ground in its portrayal of the city in broad daylight. Another sketch of a different town (no. 88) is even less finished. Church has outlined most of the buildings in pencil only and then has used oils minutely to depict a view under an arched bridge and the top of an old bell-tower. His vision is more intense and his brush more certain than in any of the other studies from the long trip.

Very different indeed are the sketches made in Greece in April of the following year, 1869. It is almost difficult to understand their coming from the same hand. The most problematic subject for Church was the ultimate classic site, the Acropolis in Athens, and it is surely not by chance that the trip to Greece was put off to the very end. Two views of the Parthenon (nos. 89 and 90) are loosely, even messily sketched. The great building remains distant, the foreground and hill undefined, and only the late afternoon light gives unity to the composition. Here there *is* good reason to think that Church used photography as a substitute for his own observation, for there are several prints at Olana (*see* plate 23) that exactly reproduce the appearance of the main temple and the single column at the right side of his painting of 1871, now in The Metropolitan Museum of Art (plate 24). In retrospect, the painting bears an unreal focus; it is more perfect, more detailed yet less convincing than any of his earlier work. Even its glowing color is somehow metallic. The work reinforces our belief that the Hudson River School esthetic had lost relevancy for Church by this time, just as it would for Gifford and Heade by the mid-1870s, and for Bierstadt shortly thereafter.

Broken Columns, View from the Parthenon (no. 91) is a fresh, *plein air* observation, but the columns still lack weight and substance, and the subject becomes trivial. More strongly brushed is *Base of a Capital, Dionysius Theatre, Athens* (no. 92); it owes its appeal to the unusual subject, on which is cast a pink, almost flesh-colored light. (Church owned a photograph of this piece, also, probably of slightly later date.) Two final views of Greece are seen in *Mount Pentelicus* (no. 93), the famous peak now shown beneath a distant horizon, and *Rocky Hilltop* (no. 94), a generalized atmospheric study that suggests something of the troublesome mystery the Old World held for the artist.

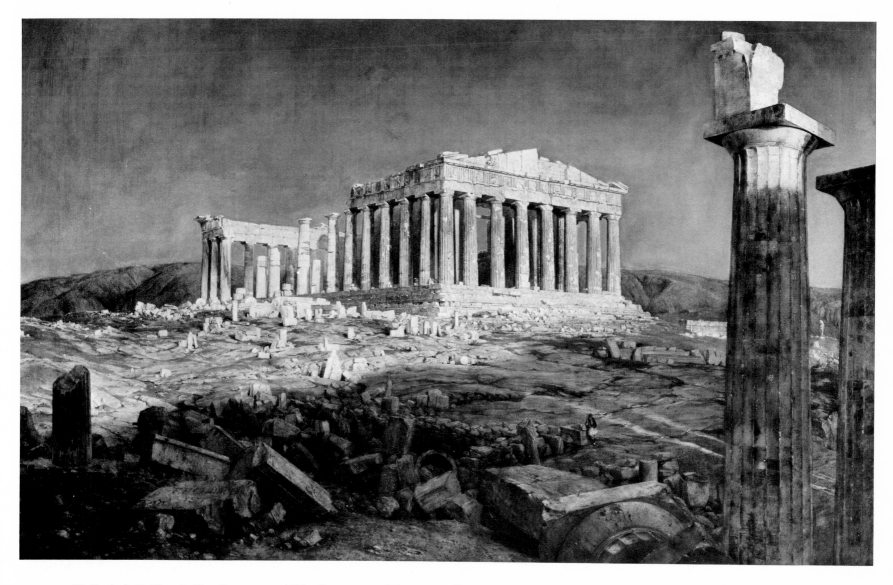

PLATE 24. Frederic E. Church, THE PARTHENON, 1871, oil on canvas (The Metropolitan Museum of Art, New York)

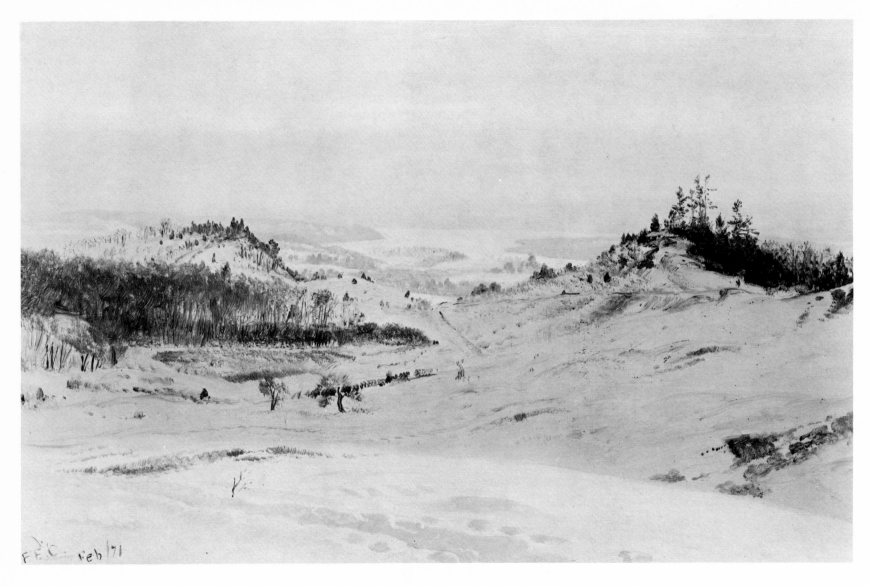

PLATE 25. Frederic E. Church, Snow Scene, Olana, 1871, oil on canvas (private collection, New York)

44

Olana and the Sky

In 1860, at the height of his career, Church bought a farm near Hudson, New York, across the river from the town of Catskill, where he had worked with Thomas Cole. In the summer of 1872, he finished construction, on the top of the hill behind his farm, of an extraordinary Victorian mansion, which he called "Olana," the center of the world. Olana remains one of the great houses in America, and its very eclecticism reflects something of the confusion found in Church's late work and that of his contemporaries. The house, like most of Church's paintings during and after his long trip, is the product of a new era, one marked by the slow, inevitable yet unknowing decline of the Ruskinian-realist esthetic of which he was champion.

Nonetheless, the oil sketches continue to demonstrate unexpected vitality at times. Both color and composition grow bolder and increasingly abstract, particularly as Church observed the scenery and the skies from his new villa. The house itself was sketched several times (*see* no. 95) but never with great success. Church also made occasional figure studies at this time (no. 96).

What stands out, however, are the pure studies of clouds and light. An anomaly in a way, for though Church's art from the beginning had depicted light with great keenness, through the first two decades of his mature career there are only occasional oil studies of these effects. In these years he seems to have used pencil sketches and color notes instead. In the mid-1860s, sunset studies such as the Jamaican ones (nos. 71, 72 and 73) appear that still include considerable foreground and topography. There are occasional sketches, such as *Hudson, New York, at Twilight* (no. 97), which surely could not have been done long after *Twilight in the Wilderness*. In this case, the concept of urban landscape as consistent with wilderness twilight points to an early date. Perhaps from the same time is the equally boldly conceived *Moonlight* (no. 98), an oil on thick composition board, not paper. Its yellow moon is eloquently placed with a tall, dark tree to the right. Both of these sketches prefigure the later ones in subject, though both are far more carefully finished than their successors.

The view from Olana down the Hudson River is spectacular, and the artist took advantage of it in many sketches made from his own property. Even as the house was being conceived, he began *High Clouds across the Hudson* (no. 99). As had now become his habit, *High Clouds* is incised with the inscription, "June/70". Largely a sky effect, like so many of the Olana studies, its sweeping, curling strokes define landscape and sky, and the tighter handling and heavier impasto are revealed along the illuminated pink edge of the great cloud. Again, Church seemed to realize the possibilities of the sketch. The topography was constant, and he could revel in recording the brilliant light effects of sunset and storm as they swept across his vision. He painted brilliant summer sunsets with long, sweeping strokes, using unmuted greens, blues and oranges (*see* no. 100), sometimes looking up and painting the reds and purples of the sky after nightfall (no. 101).

During the winters he would paint the same view. One of the most notable examples is now in a private collection (plate 25); other, even less formal studies are at Olana and the Cooper-Hewitt (*see* nos. 102 and 103). Church used no pencil at all in these late works. *Winter Landscape at Sunset* (no. 102) is particularly effective in its freshness and in the contrast of orange light, the dark purple hills to the right and the gray, stormy sky above.

The sketches become increasingly effective and increasingly abstract. In one series, the artist takes a notably high vantage point and looks to the western sky over Quarry Hill. *Tree and Sky, Distant View* (no. 104), in which a single, calligraphic pine rises up into layers of winter mist, seems orientally conceived. In *Cloud Study, above Winter Landscape* (no. 105), the artist has dragged thin paint over a lightly textured board. Touching and poetic, the work displays a pale palette with powdery grays, blues and yellows and suggests the work of the German Romantic, Caspar David Friedrich. In *Cloud Study,* oil is used as much like watercolor as possible, though watercolor was rarely employed either by Church or by his Hudson River School contemporaries. Two further studies from Quarry Hill are even more rapid, more consumed with color for its own sake (nos. 106 and 107). They are small in scale but powerful, commanding works of art.

At this point during the 1870s, Church was approaching, in his sky studies, Constable's atmospheric oil sketches of a half-century earlier. As early as 1847, the American, Jasper Cropsey, had reported, on arriving in England, that among the artists there a "veritable cloud cult," was buoyed by the "romantic utterances of the local literati, especially Coleridge, Wordsworth, Shelley, and Ruskin, along with several treatises on cloud formation by the scientist Luke Howard . . . all symptomatic of the new and extensive awareness of celestial phenomena".[46] Interest in skies was not new, and the examples of Constable and Turner were well-known to American artists. There is no record of Church's having seen Constable's work, though Huntington records that in London he visited the basement of the National Gallery of Art to see Turner's "smaller pictures and sketches";[47] certainly it is possible that he would have seen some Constables on the same trip.

By far the most successful of the late sketches are the skies. Judging from the use of red ground and the relatively tight construction, one of the pure cloud studies (no. 108) appears to date from early in his career and would stand as a predecessor to the later studies. In *Cloud Study, Yellow Sunset,* dated March 1871 (no. 109), the creamy yellow clouds on pale tan ground again suggests Constable (*see* plate 26), as does *Sunset Study* (no. 110), with its yellows, corals and purples. Yet Church's concern was color, and his time, sunset; Constable, in contrast, was more typically a painter of cool, cloudy skies, and the shape of the clouds interested him far more than they did Church. Though both artists studied light as it reflected upon clouds, Constable's studies remain more formal than Church's. Church's brushwork becomes ever-looser and less literal. In the late works, those thought of as culminant in this medium (nos. 111 and 112), color has become everything for Church. Clouds, lit with dazzling color—pinks and corals in one, purples and oranges in the other—seem to breathe and dance above the horizon. The voyager and artist, the master of topography, the scientist, becomes the expressionist as he revels in the extraordinary shapes and colors of the sky.

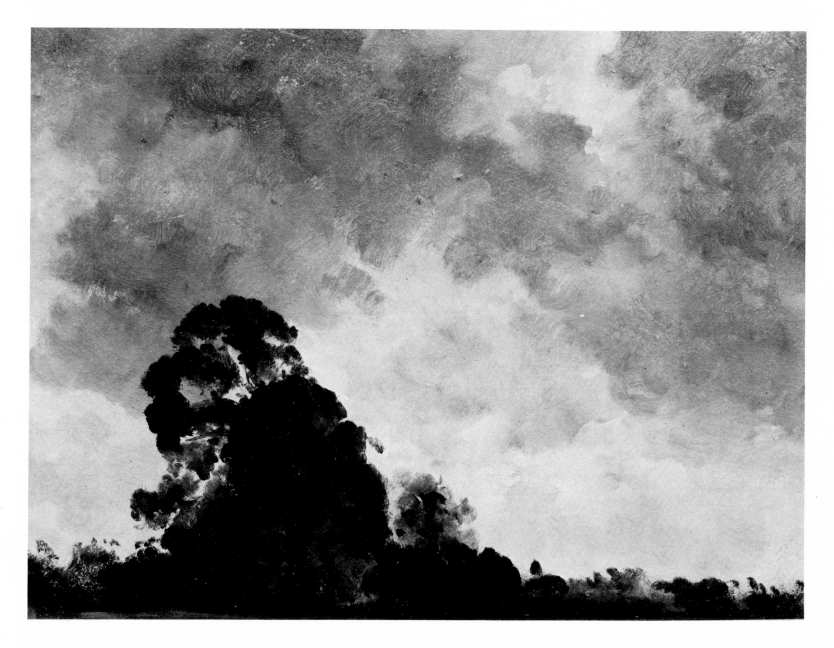

PLATE 26. John Constable, LANDSCAPE AT HAMPSTEAD, TREES AND STORMCLOUDS, *ca.* 1815–
1820, oil on wood (The Yale Center for British Art and British Studies, New Haven, Conn.)

Notes

1. "Church the Artist," *Brooklyn Eagle*, New York (April 15, 1900), cited by David C. Huntington, *The Landscapes of Frederic Edwin Church* (New York, 1966), p. 2.

2. Huntington, *Landscapes of Church*, p. 8.

3. *Art Journal*, London (October 1859), cited by Huntington, *Landscapes of Church*, p. 1.

4. Asher B. Durand, "Letters on Landscape Painting," Letter 1, *The Crayon* 1 (January 1855): 2.

5. William Gilpin, *Five Essays on Picturesque Subjects with a Poem on Landscape Painting*, 3d ed. (London, 1808), pp. 50–51.

6. Henry David Thoreau, *Walden*.

7. Letter of Thomas Cole to Robert Gilmor, cited by Howard S. Merritt, "A Wild Scene, Genesis of a Painting," *Studies on Thomas Cole, An American Romanticist*, Annual II (Baltimore: The Baltimore Museum of Art, 1967), pp. 79–80.

8. Alfred Frankenstein, *William Sidney Mount* (New York, 1975), p. 185.

9. Ibid., p. 181.

10. Durand, "Letters," Letter 2, p. 34.

11. Durand, "Letters," Letter 5 (March 1855) : 145.

12. John Durand, *The Life and Times of A. B. Durand* (New York, 1894; reprint ed., Da Capo Press, 1970), p. 151.

13. Albert Boime, *The Academy and French Painting in the Nineteenth Century* (London, 1971), p. 81.

14. Pierre Henri de Valenciennes, *Eléments de perspective practique à l'usage des artistes, suivis de réflexions et de conseils à un élève sur la peinture et particulièrement sur le genre du paysage* (Paris, 1800).

15. "The Forest of Fontainebleau, Refuge of Reality: French Landscape 1800 to 1870," *exhibition catalogue* (Shepherd Gallery, New York: Apr. 22–June 10, 1972), no. 1.

16. "A Decade of English Naturalism: 1810–1820," *exhibition catalogue with essay by John Gage* (Norwich Castle Museum, 1969; Victoria and Albert Museum, 1970), p. 16.

17. Louis Hawes, Jr., *John Constable's Writings on Art* (Ann Arbor, London: University Microfilms, Inc., 1963), pp. 371–72.

18. Graham Reynolds, *Constable*, p. 86.

19. *The Crayon* 1 (March 1855): 203.

20. David C. Huntington, "Frederic Edwin Church, 1826–1900: Painter of the Adamic New World Myth" (Ph.D. dissertation, Yale University, 1960; Ann Arbor, London: University Microfilms, 1969), p. 129.

21. Alexander von Humboldt, *Views of Nature or Contemplations on the Sublime: Phenomena of Creation with Scientific Illustrations* (London, 1850), pp. 229–30.

22. Alexander von Humboldt, *Cosmos: A Sketch of a Physical Description of the Universe* (London, 1849), p. 452.

23. *The Crayon* 5 (January 1858): 24, cited by Huntington, "Frederic Church," p. 105.

24. *The Crayon* 4 (February 1857): 54.

25. Ibid., (May 1857): 157.

26. "Church the Artist," cited by Huntington, *Landscapes of Church*, p. 2.

27. Henry Theodore Tuckerman, *Book of the Artists* (New York, 1867), p. 371, cited by Huntington, "Frederic Church," p. 88.

28. Huntington, "Frederic Church," p. 95.

29. Ibid., p. 94.

30. Ibid., p. 115.

31. Tuckerman, *Book of Artists*, p. 381.

32. Ibid.

33. Louis Legrand Noble, *After Icebergs with a Painter: A Summer Voyage to Labrador and Around Newfoundland* (New York, 1861), p. 77.

34. Ibid., pp. 54–56.

35. Gordon Hendricks, *Albert Bierstadt, Painter of the American West* (New York, 1974), p. 126.

36. Noble, *After Icebergs*, pp. 45–46.

37. Tuckerman, *Book of Artists*, p. 381.

38. Huntington, "Frederic Church," p. 132.

39. Ibid., p. 141.

40. Tuckerman, *Book of Artists*, p. 386.

41. *See* Elizabeth Lindquist-Cock, *The Influence of Photography on American Landscape Painting, 1839–1880*, dissertation (New York and London, 1977), pp. 99–122. The writer mistakenly compares *Morning in the Tropics*, 1877, with the photograph illustrated in plate 34, of which she writes "Photographer unknown (Muybridge ?)", when in fact the print is a signed and dated work of 1896 by the Englishman, Samuel Bourne (1834–1912).

42. Petra Diary (1868), cited by Huntington, "Frederic Church," pp. 164–65.

43. Ibid., p. 169.

44. William J. Stillman, *The Autobiography of a Journalist, vol. 1* (Boston and New York, 1901), p. 114.

45. Huntington, "Frederic Church," p. 185.

46. "Jasper F. Cropsey, 1823–1900," *exhibition catalogue with essay by William S. Talbot* (Washington, D.C.: National Collection of Fine Arts, Smithsonian Institution Press, 1970), p. 11.

47. Huntington, "Frederic Church," p. 155.

List of Short Titles

1. AMHERST–COE KERR, 1975
"American Painters of the Arctic."
Exhibition catalogue: Amherst College, Mass., Feb. 1–28, 1975; Coe Kerr Gallery, Mar. 11–Apr. 5, 1975.

2. CHICAGO–WHITNEY, 1945
"The Hudson River School and the Early American Landscape Tradition."
Exhibition catalogue: The Art Institute of Chicago, Feb. 12–Mar. 25; Whitney Museum of American Art, New York, Apr. 17–May 18, 1945.

3. CLAREMONT–WELLESLEY, 1975–1976
"Frederic E. Church."
Exhibition: Galleries of the Claremont Colleges, Calif., Nov. 6–Dec. 19, 1975; Fine Arts Gallery of San Diego, Jan. 10–Feb. 29, 1976; University of Minnesota, Mar. 29–May 9, 1976; Wellesley College Museum, Sept. 9–Oct. 31, 1976.

4. COLBY, 1966
"Art in the Making."
Exhibition: Colby College Art Museum, Waterville, Me., July–Sept., 1966.

5. CORCORAN, *American Muse,* 1959
"The American Muse—Parallel Trends in Literature and Art."
Exhibition catalogue: Corcoran Gallery of Art, Washington, D.C., Apr. 4–May 17, 1959.

6. CORCORAN, 1971
"Wilderness."
Exhibition catalogue: Corcoran Gallery of Art, Oct. 1–Nov. 14, 1971.

7. DETROIT, 1944
"The World of the Romantic Artist."
Exhibition catalogue: Detroit Institute of Arts, Mich., Dec. 28, 1944–Jan. 28, 1945.

8. GRAHAM, 1974
"Frederic Edwin Church."
Exhibition: Graham Gallery, New York, Dec. 17, 1974–Jan. 11, 1975.

9. HUNTINGTON, 1966
Huntington, David C. *The Landscapes of Frederic Edwin Church, Vision of an American Era.* New York: George Braziller, 1966.

10. ITHACA, 1971; circulated by AFA Circulating Program, 1972
"Drawn from Nature/Drawn from Life: Studies and Sketches by Frederic Church, Winslow Homer and Daniel Huntington from the Collection of the Cooper-Hewitt Museum of Decorative Arts & Design, Smithsonian Institution."
Exhibition catalogue: Ithaca College Museum of Art, N.Y., Mar. 23–Apr. 18, 1971.

11. JOSELOFF, 1974
"Frederic Edwin Church: The Artist at Work."
Exhibition catalogue: Joseloff Gallery, Hartford Art School, West Hartford, Conn., Oct. 11–Nov. 1, 1974.

12. MOMA, 1976
"The Natural Paradise: Painting in America, 1800–1950."
Exhibition catalogue: The Museum of Modern Art, New York, Sept. 29–Nov. 30, 1976.

13. NCFA–KNOEDLER, 1966
"Frederic Edwin Church."
Exhibition catalogue: National Collection of Fine Arts, Washington, D.C., Feb. 9–Mar. 13; Albany Institute of History and Art, N.Y., Mar. 30–Apr. 30; M. Knoedler & Co., New York, June 1–30, 1966.

14. RICHARDSON, 1944
Richardson, Edgar P. *American Romantic Painting.* New York: E. Weyhe, 1944.

15. SITES, 1975
"American Art in the Making: Preparatory Studies for Masterpieces of American Painting, 1800–1900."
Exhibition catalogue: SITES, Washington, D.C., Aug. 31, 1975–Jan. 31, 1977.

16. SITES, 1966
"Sketches by Frederic Edwin Church."
Exhibition: SITES, July 16, 1966–Feb. 4, 1968.

17. STEADMAN, 1976
Steadman, David. "Oil Sketches by Frederic E. Church." *American Art Review* 3:1 (Jan.–Feb. 1976).

18. WILMINGTON, 1962
"American Painting, 1857–1869."
Exhibition catalogue: Wilmington Society of Fine Arts, University of Delaware, Jan. 10–Feb. 18, 1962.

19. YOUNG, 1959
Young, Vernon. "The Changing Landscape in American Art." *Arts Yearbook* 2 (1959).

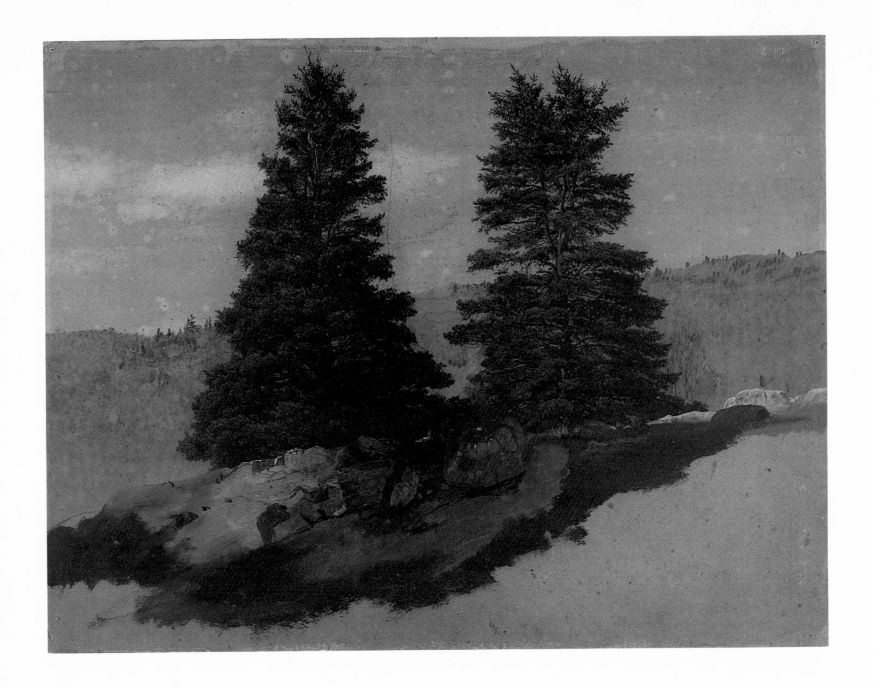

50

Catalogue of the Exhibition

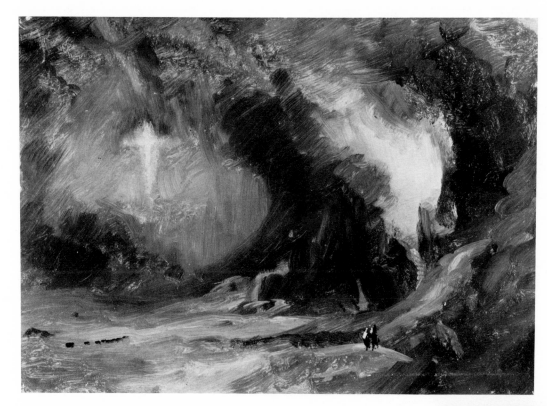

Dimensions are given in inches and centimeters; height precedes width.

1. APOTHEOSIS TO THOMAS COLE

Oil on paperboard; 7⅛ in x 10⅛ in (18.0 cm x 25.6 cm)

Date: ca. 1848

Cooper-Hewitt 1917-4-254B

Exhibited: NCFA–Knoedler, 1966, no. 150; Graham, 1974; Claremont-Wellesley, 1975–1976

BELOW:

2. WOODLAND VALLEY, AUTUMN

Oil on paper; 12 in x 15⅜ in (30.5 cm x 39.1 cm)

Date: 1848, September

Cooper-Hewitt 1917-4-722

OPPOSITE PAGE:

3. TWO PINE TREES

Oil with pencil on composition board; 12¼ in x 16¼ in (30.8 cm x 40.8 cm)

Date: ca. 1849–50

Cooper-Hewitt 1917-4-657B

Exhibited: Graham, 1974; Claremont-Wellesley, 1975–1976

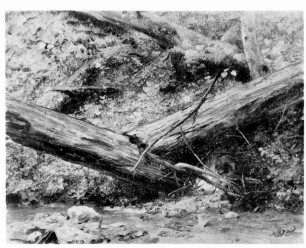

5. CAMPFIRE: MAINE WOODS

Oil on paperboard; 9¾ in x 13 in (24.8 cm x 33.1 cm)

Date: ca. 1850–55

Cooper-Hewitt 1917-4-854

Exhibited: "Maine and Its Artists 1717–1963," exhibition catalogue, Waterville, Me., Colby College Art Museum, May 4–Aug. 31, 1963; Boston, Museum of Fine Arts, Dec. 12, 1963– Jan. 26, 1964; New York, Whitney Museum of American Art, Feb. 10–Mar. 22, 1964, no. 26.

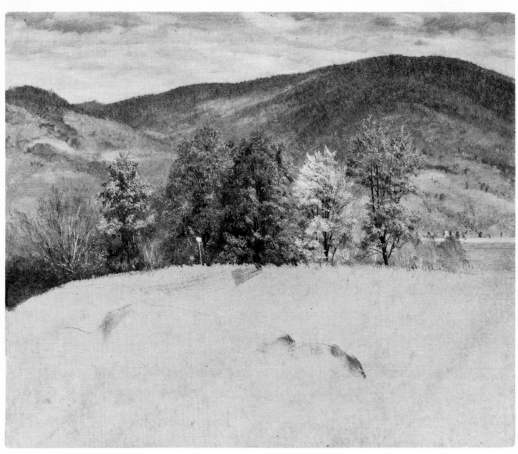

4. AUTUMN FOLIAGE, VERMONT

Oil with pencil on paperboard; 9¾ in x 12 in (24.7 cm x 30.4 cm)

Date: ca. 1850

Cooper-Hewitt 1917-4-717

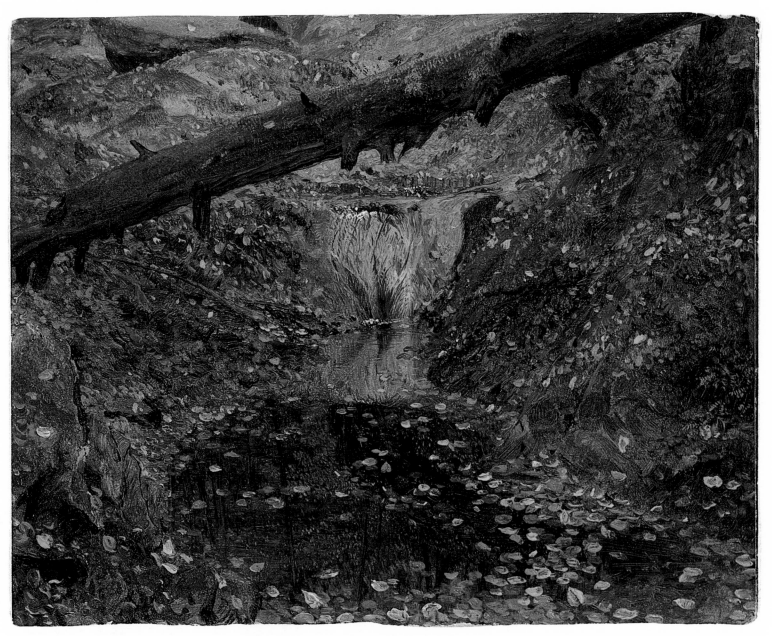

6. WOODLAND STREAM, LATE AUTUMN
Oil on paperboard; 9¼ in x 11¾ in (23.5 cm x 29.8 cm)
Date: ca. 1850–55

Cooper-Hewitt 1917-4-669B

7. A CORNER OF A POND

Oil on paperboard; 6⅛ in x 10¼ in (15.5 cm x
25.9 cm)

Date: ca. 1850–60

Cooper-Hewitt 1917-4-47

9. A ROAD INTO THE WOODS

Oil with pencil on paperboard; 10⅞ in x 12⅜ in
(27.7 cm x 31.4 cm)

Date: 1855–60

Cooper-Hewitt 1917-4-589A

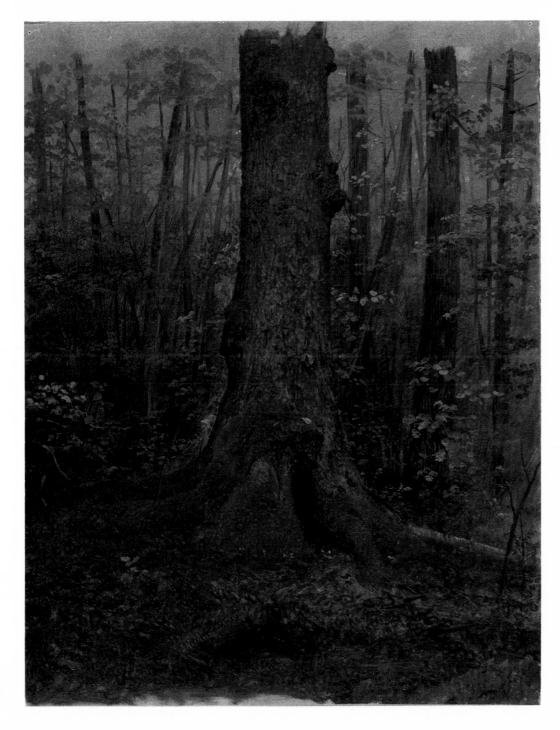

8. A GREAT TREE: DEEP WOODS

Oil with pencil on paperboard; 14⅛ in x 11⅛ in (35.9 cm x 28.2 cm)

Date: 1855–60

Cooper-Hewitt 1917-4-589C

Exhibited: Cambridge, Mass., Fogg Art Museum, "Luminous Landscape, the American Study of Light, 1860–1875," 1966; Ithaca, 1971; AFA Circulating Program, 1972

10. A MAPLE TREE, AUTUMN

Oil on paperboard; 12 in x 8¾ in (30.5 cm x 22.1 cm)

Inscribed l.r.: "Oct.–60"

Cooper-Hewitt 1917-4-709

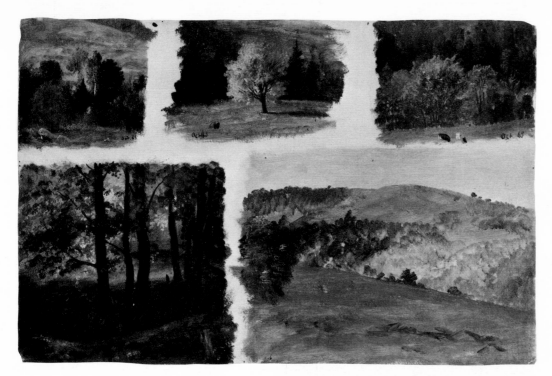

11. AUTUMN FOLIAGE: FIVE STUDIES

Oil on paperboard; 11¾ in x 18⁹⁄₁₆ in (30.0 cm x 47.1 cm)

Each, except l.r. inscribed: "Oct.–65"

Cooper-Hewitt 1917-4-764

Exhibited: Graham, 1974; Claremont-Wellesley, 1975–1976

Bibliography: Steadman (1976), p. 120

13. THE COAST AT MOUNT DESERT

Oil with pencil on composition board; 12 in x 16 in (30.6 cm x 40.7 cm)

Date: ca. 1850

Inscribed l.l.: "Watson"

Cooper-Hewitt 1917-4-645

Exhibited: Joseloff, 1974, no. 29; Graham, 1974; Claremont-Wellesley, 1975–1976

Bibliography: Huntington (1966), no. 12

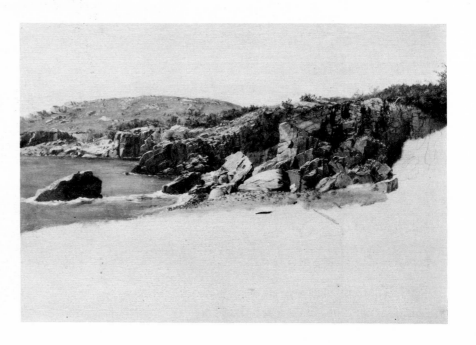

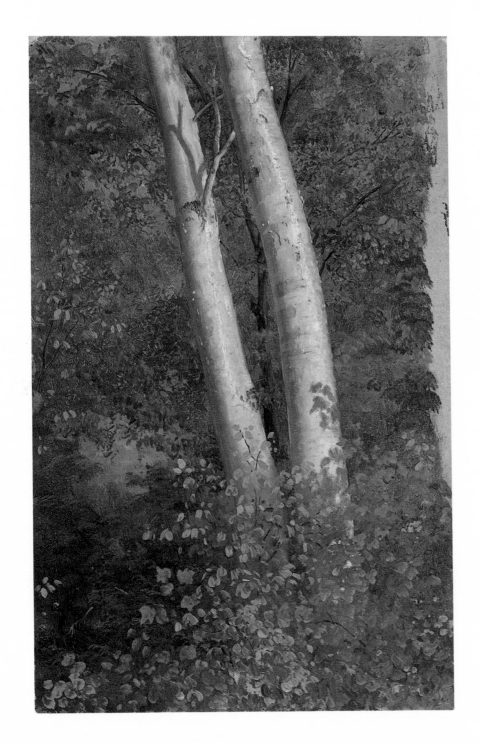

12. BIRCH TREES IN AUTUMN
Oil on paperboard; 12 in x 7⅝ in (30.5 cm x 19.4 cm)
Inscribed l.r.: "Oct.–65"
Cooper-Hewitt 1917-4-659A

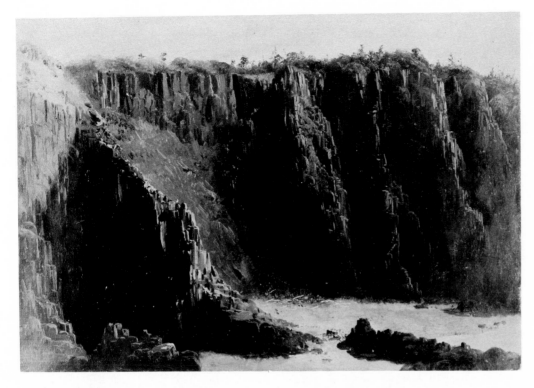

15. Cliffs at Grand Manan

Oil with pencil on composition board; 11⅛ in x 16 in (28.3 cm x 40.6 cm)

Date: ca. 1851–52

Cooper-Hewitt 1917-4-658

Exhibited: Detroit, 1944, no. 66; Corcoran, 1971, no. 57

Bibliography: Richardson, Edgar P., *American Romantic Painting* (New York, 1944), p. 29, illus. 187

OPPOSITE PAGE:

14. Sharp Rocks off Grand Manan

Oil with pencil on composition board; 12 in x 16 in (30.8 cm x 40.7 cm)

Date: ca. 1851–52

Cooper-Hewitt 1917-4-649C

Exhibited: Graham, 1974; Claremont-Wellesley, 1975–1976

16. Rocks and Moss off Grand Manan

Oil on composition board; 9⅞ in x 16¹⁄₁₆ in (25.1 cm x 40.8 cm)

Date: ca. 1851–52

Inscribed verso: "Grand Manan"

Cooper-Hewitt 1917-4-795

Exhibited: Trinity School, New York, "Nineteenth Century Romantic Painting," 1965; NCFA–Knoedler, 1966, no. 21; Corcoran, 1971, no. 56; Graham, 1975; Claremont-Wellesley, 1975–1976

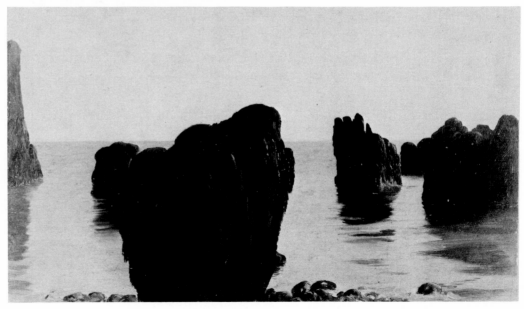

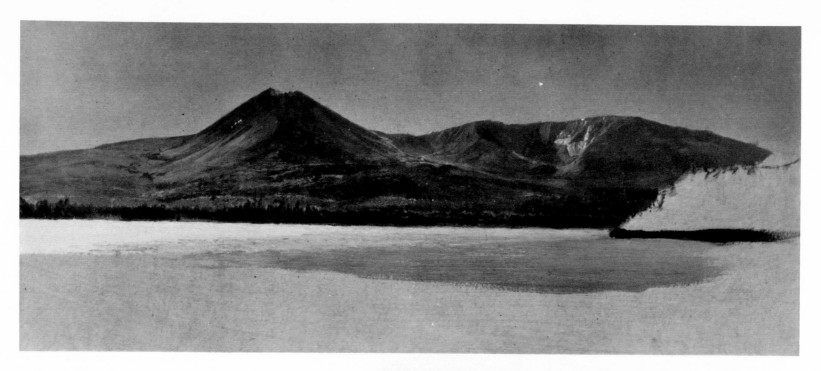

18. MOUNTS KATAHDIN AND TURNER FROM
 LAKE KATAHDIN

Oil with pencil on paperboard; 12⅛ in x 20 in
(30.6 cm x 50.8 cm)

Date: ca. 1860–75

Inscribed verso: "Katahdin"

Cooper-Hewitt 1917-4-626

Exhibited: NCFA–Knoedler, 1966, no. 42;
SITES, 1966; Graham, 1974; Claremont-
Wellesley, 1975–1976

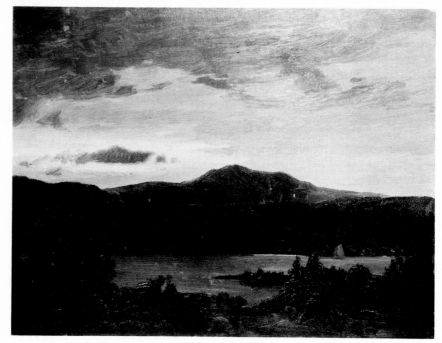

17. MOUNT KATAHDIN FROM LAKE KATAHDIN

Oil on paperboard; 9 in x 12 in (22.8 cm x
30.2 cm)

Date: ca. 1850–53

Cooper-Hewitt 1917-4-323C

Exhibited: Lincoln, Nebr., University of
Nebraska Art Galleries, "The Painter and the
Mountain," 1957; Graham, 1974

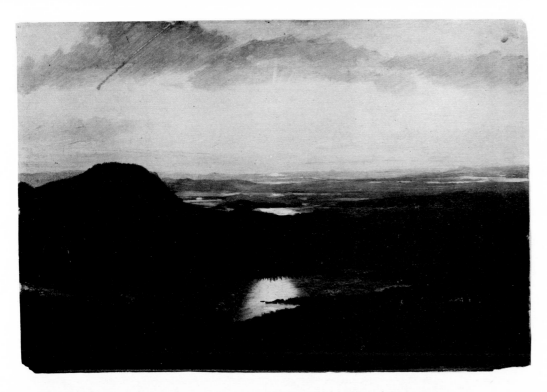

19. EAGLE LAKE VIEWED FROM CADILLAC
 MOUNTAIN

Oil with pencil on paperboard; 12 in x 17½ in
(29.0 cm x 44.6 cm)

Date: ca. 1850–60

Inscribed verso: "Mt. Desert"

Cooper-Hewitt 1917-4-324

Exhibited: Detroit, 1944, no. 73; NCFA–
Knoedler, 1966, no. 28

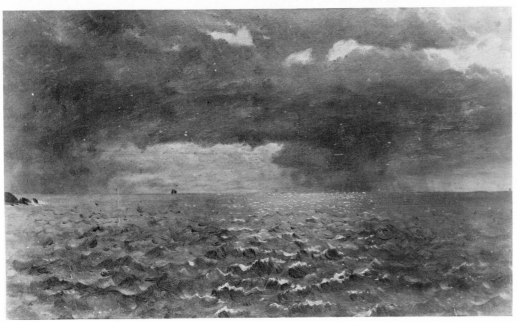

20. STORMY SEA

Oil with pencil on paper; 8¼ in x 14 in (21.0
cm x 35.5 cm)

Date: ca. 1855–60

Cooper-Hewitt 1917-4-867

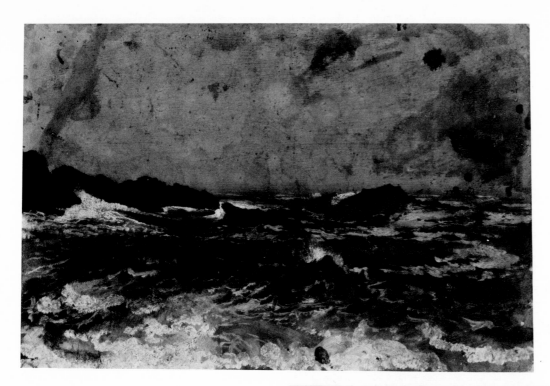

21. STUDY OF WAVES, MAINE

Oil with pencil on composition board; 8 in x 12 in (20.1 cm x 30.7 cm)

Date: ca. 1855–60

Inscribed verso: "AMOS" (?)

Cooper-Hewitt 1917-4-329

OPPOSITE PAGE:

22. MAINE SURF

Oil on paperboard; 12 in x 16 in (30.7 cm x 40.8 cm)

Date: ca. 1855–60

Cooper-Hewitt 1917-4-798A

Exhibited: Graham, 1974; Claremont-Wellesley, 1975–1976

23. SKETCH FOR "SUNRISE OFF THE MAINE COAST"

Oil on paperboard; 12 in x 20 in (30.0 cm x 50.7 cm)

Date: ca. 1855–60

Cooper-Hewitt 1917-4-1324

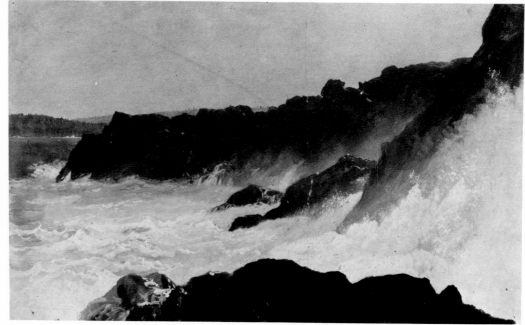

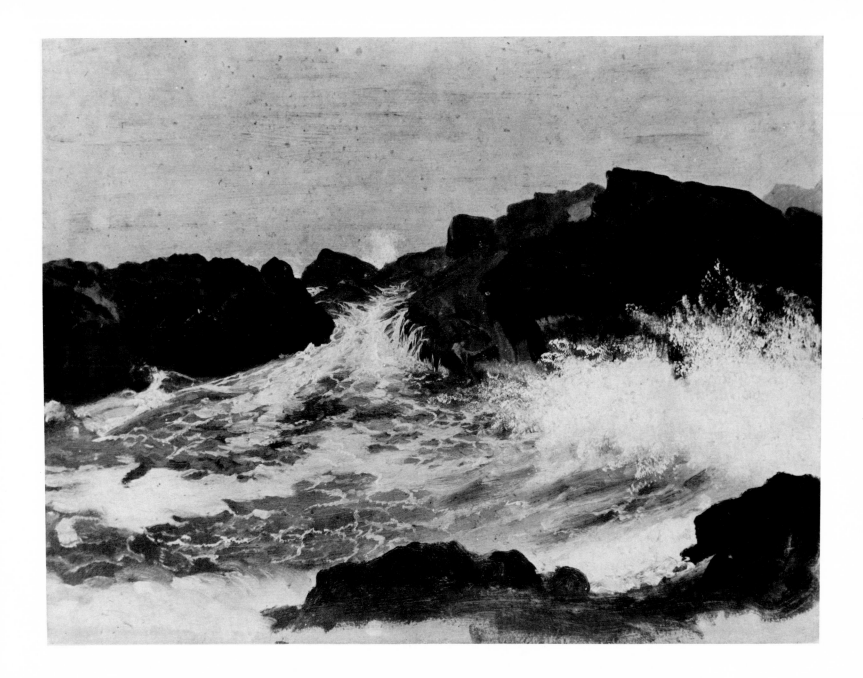

63

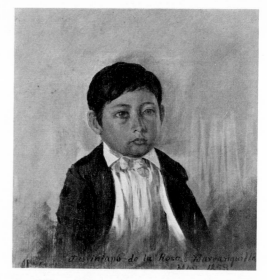

25. JUSTINIANO DE LA ROSA

Oil on paperboard; 8⅞ in x 8½ in (22.6 cm x 21.5 cm)

Inscribed: "11 years Justiniano de la Rosa. Barranquilla/May 1853"

Cooper-Hewitt 1917-4-713

Exhibited: NCFA–Knoedler, 1966, no. 59

24. COLOMBIAN WATERFALL

Oil on paperboard; 12⅜ in x 17⅜ in (31.6 cm x 44.2 cm)

Inscribed l.l.: "June 53"

Cooper-Hewitt 1917-4-705

26. COTOPAXI FROM AMBATO, ECUADOR

Oil with pencil on paperboard; 6⅞ in x 11⅜ in (17.5 cm x 29.0 cm)

Date: 1853

Cooper-Hewitt 1917-4-773

Exhibited: SITES, 1975, no. 21, fig. 34

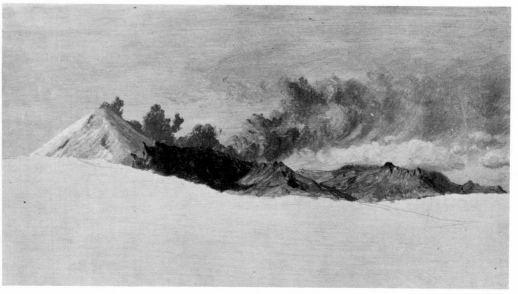

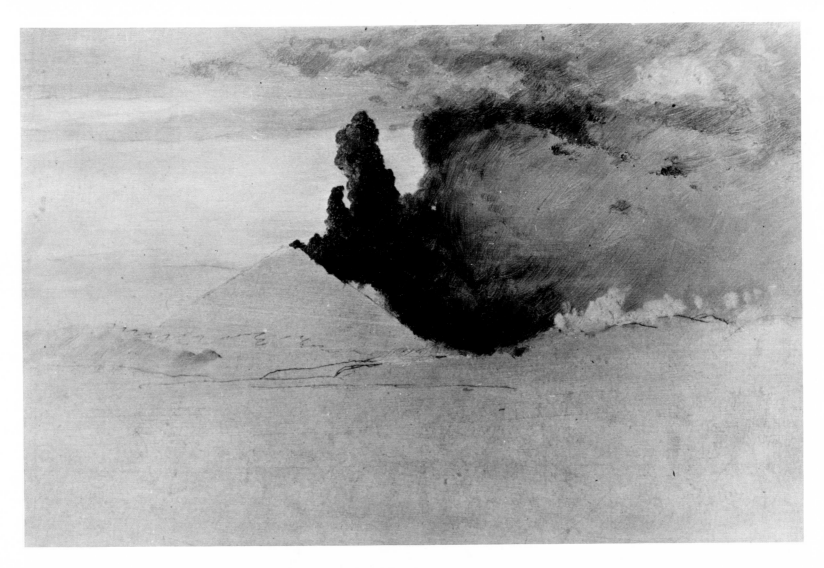

27. STUDY OF COTOPAXI ERUPTING

Oil with pencil on paperboard; 7⅜ in x 11⅝ in
(18.9 cm x 29.7 cm)

Date: 1853

Cooper-Hewitt 1917-4-786

Exhibited: SITES, 1975, no. 22, fig. 35

Bibliography: Huntington (1966), no. 34

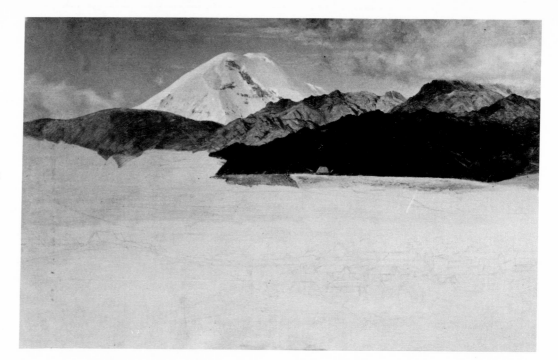

28. Chimborazo from the Town of Guaranda

Oil with pencil on paperboard; 13⅝ in x 21¼ in
(34.5 cm x 53.9 cm)

Date: 1857

Cooper-Hewitt 1917-4-859

Exhibited: Colby, 1966; Graham, 1974

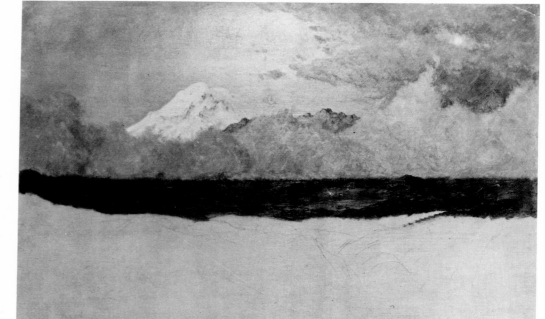

**29. Chimborazo Seen through Rising Mists
 and Clouds**

Oil with pencil on paperboard; 13⅝ in x 21¼ in
(34.6 cm x 54.0 cm)

Date: 1857

Cooper-Hewitt 1917-4-824

Exhibited: Graham, 1974; SITES, 1975, no. 18,
fig. 31

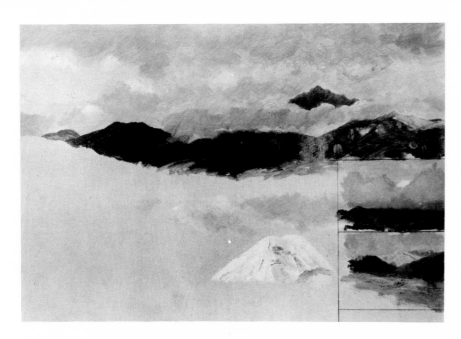

30. A Sheet of Studies of Chimborazo

Oil with pencil on paperboard; 11¾ in x 17⅝ in
(29.8 cm x 44.7 cm)

Date: 1857

Cooper-Hewitt 1917-4-825

Exhibited: Graham, 1974; SITES, 1975

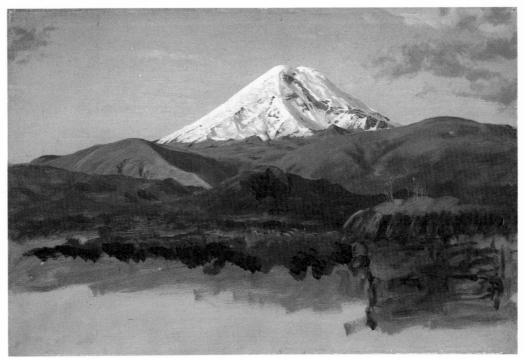

31. Mount Chimborazo

Oil with pencil on paperboard; 13⅝ in x 21 in
(34.5 cm x 53.2 cm)

Date: 1857

Cooper-Hewitt 1917-4-1296B

Exhibited: NCFA–Knoedler, 1966, no. 72;
Ithaca, 1971, no. 2; AFA Circulating Program,
1972; Graham, 1974; Claremont-Wellesley,
1975–1976

33. Horseshoe Falls from Canada

Oil with pencil on paperboard; 11⅝ in x 17½ in (29.5 cm x 44.5 cm)

Date: 1856

Cooper-Hewitt 1917-4-766A

Exhibited: Corcoran, 1971, no. 61; Joseloff, 1974, no. 38; Graham, 1974

Bibliography: Alfred Runte, "Beyond the Spectacular: The Niagara Falls Preservation Campaign," *The New York Historical Society Quarterly* 57 (January 1973): p. 44

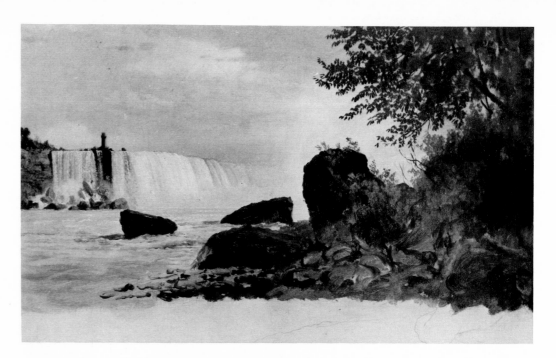

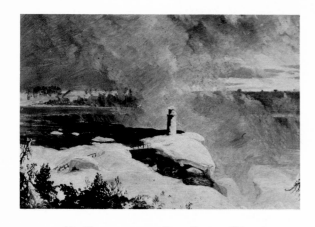

32. Niagara from Goat Island, Winter

Oil on composition board; 11½ in x 17⅜ in (29.3 cm x 44.0 cm)

Inscribed l. center: "F. Church 56/March"

Cooper-Hewitt 1917-4-765A

Exhibited: NCFA–Knoedler, 1966, no. 30; SITES, 1966; Bloomington, 1970; Graham, 1974; Claremont-Wellesley, 1975–1976

Bibliography: Steadman (1976), p. 116

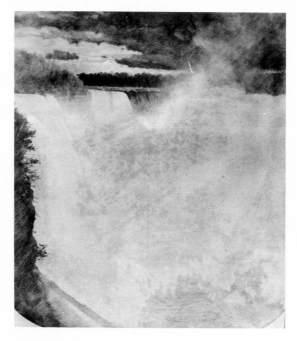

35. Niagara: Oil Sketch over a Photograph

Oil over a photograph; 12⅞ in x 11⅝ in (32.7 cm x 29.5 cm)

Date: ca. 1862–67

Cooper-Hewitt 1917-4-1350

Exhibited: Corcoran, 1971, no. 58; Joseloff, 1974, no. 40; SITES, 1975, no. 23, fig. 37

Bibliography: Van Deren Coke, *The Painter and the Photograph* (Albuquerque: University of New Mexico Press, 1972), p. 200, pl. 420

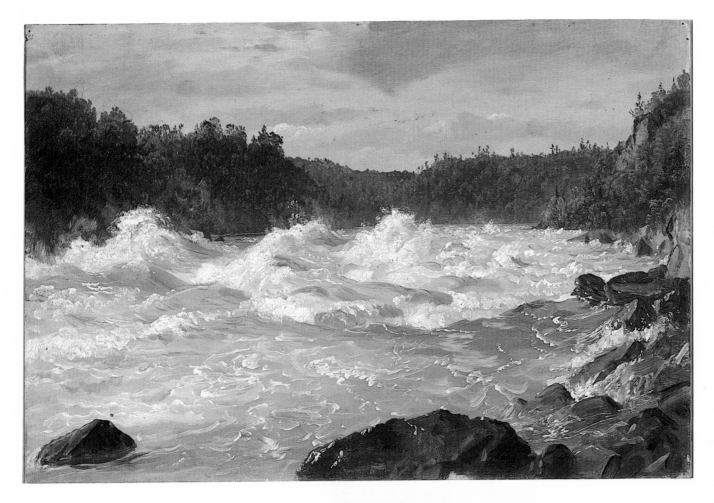

34. THE GORGE, NIAGARA

Oil on composition board; 10¾ in x 16⅛ in
(27.3 cm x 40.8 cm)

Date: ca. 1856–57

Cooper-Hewitt 1917-4-168

Exhibited: NCFA–Knoedler, 1966, no. 33;
SITES, 1966; Joseloff, 1974, no. 37; Graham,
1974; Claremont-Wellesley, 1975–1976

Bibliography: Huntington (1966), no. 48

36. AT THE BASE OF THE FALLS

Oil on paperboard; 11⅝ in x 13¾ in (29.5 cm
x 35.0 cm)

Date: ca. 1857–67

Cooper-Hewitt 1917-4-1353

Exhibited: NCFA–Knoedler, 1966, no. 32;
Joseloff, 1974, no. 39; SITES, 1975, no. 24

37. ICEBERG FANTASY

Oil on canvas; 5½ in x 6⅞ in (14.0 cm x 17.4 cm)

Date: 1859

Cooper-Hewitt 1917-4-748

Exhibited: Corcoran, *American Muse,* 1959, no. 47; Wilmington, 1962, no. 11; Graham, 1974; Claremont-Wellesley, 1975–1976

Bibliography: Young (1959), p. 106

38. STUDY OF SHIPS IN THE NORTH

Oil with pencil on paperboard; 9⅛ in x 12⅞ in (23.3 cm x 32.8 cm)

Date: 1859, June–July

Cooper-Hewitt 1917-4-390

Exhibited: NCFA–Knoedler, 1966, no. 99; Graham, 1974; Amherst–Coe Kerr, 1975, no. 4

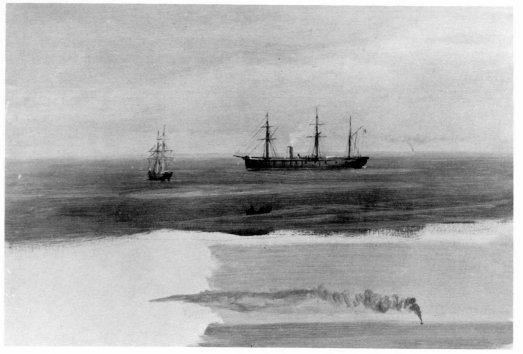

39. ICEBERGS IN THE DISTANCE

Oil with pencil on paperboard; 7⅛ in x 10⅛ in (18.1 cm x 25.6 cm)

Date: 1859, June–July

Cooper-Hewitt 1917-4-667

BELOW:

40. ICEBERG, NEWFOUNDLAND

Oil on paperboard; 5 in x 11⅛ in (12.9 cm x 28.3 cm)

Date: 1859, June

Inscribed verso: "Off Iceberg/New Foundland"

Cooper-Hewitt 1917-4-714B

Exhibited: NCFA–Knoedler, 1966, no. 98; SITES, 1966

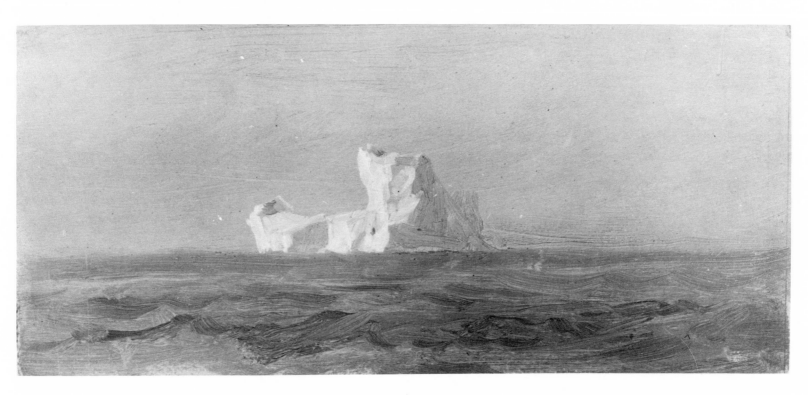

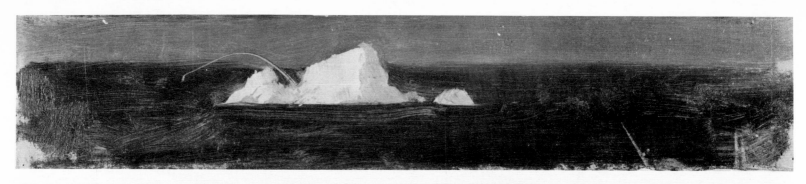

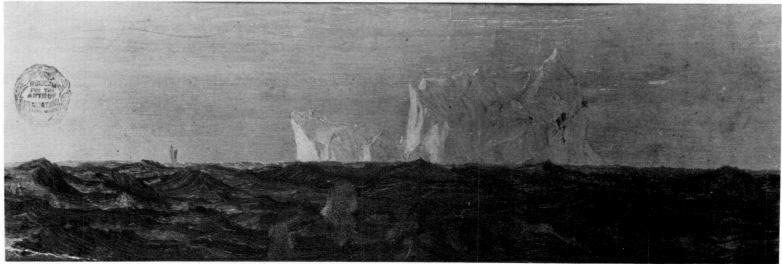

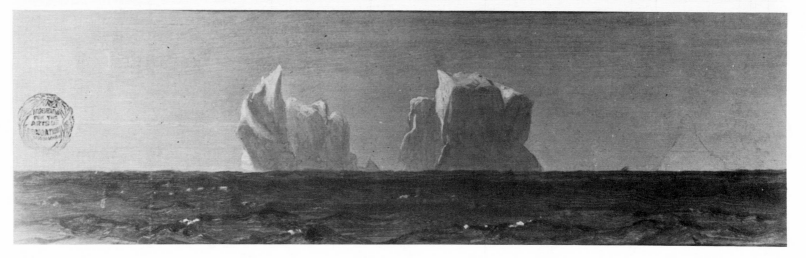

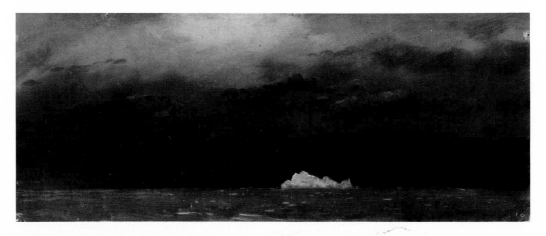

OPPOSITE, ABOVE:

41. **ICEBERG IN CALM SEAS**

Oil on paperboard; 2⅜ in x 11½ in (6.0 cm x 29.2 cm)

Date: 1859, June–July

Cooper-Hewitt 1917-4-749B

Exhibited: Corcoran, 1971, no. 68; Amherst–Coe Kerr, 1975, no. 7

OPPOSITE, MIDDLE:

42. **STUDY OF AN ICEBERG, DARK SEA**

Oil with pencil on paperboard; 4¹⁄₁₆ in x 11⅛ in (10.3 cm x 28.4 cm)

Date: 1859, June–July

Cooper-Hewitt 1917-4-290B

Exhibited: Detroit, 1944, no. 69; Corcoran, 1971, no. 66; Amherst–Coe Kerr, 1975, no. 5

OPPOSITE, BELOW:

43. **TWO ICEBERGS**

Oil with pencil on paperboard; 3¾ in x 11 in (9.5 cm x 27.9 cm)

Date: 1859, June–July

Cooper-Hewitt 1917-4-290A

Exhibited: Detroit, 1944, no. 69; Corcoran, 1971, no. 65; Amherst–Coe Kerr, 1975, no. 6

RIGHT:

45. **ICEBERGS, TONILLIGUET**

Oil on paperboard; 12 in x 18 in (30.5 cm x 45.7 cm)

Inscribed verso: "Tonilliguet 4th July/59"

Cooper-Hewitt 1917-4-294A

Exhibited: NCFA–Knoedler, 1966, no. 103; SITES, 1966; Joseloff, 1974, no. 48; Graham, 1974; Amherst–Coe Kerr, 1975, no. 12; Claremont-Wellesley, 1975–1976

Bibliography: Richard McLanathan, *The American Tradition in the Arts* (New York, 1968), p. 251

44. **ICEBERG, ST. LEWIS BAY, NEWFOUNDLAND**

Oil with pencil on paperboard; 5⅜ in x 13⅞ in (13.8 cm x 35.2 cm)

Date: 1859, June–July

Inscribed verso: "Battle Harbor St. Lewis Bay"

Cooper-Hewitt 1917-4-296C

Exhibited: NCFA–Knoedler, 1966, no. 98; Graham, 1974; MOMA, 1976

Bibliography: Huntington (1966), no. 66

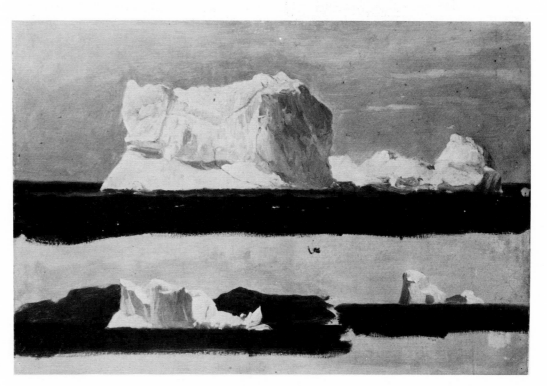

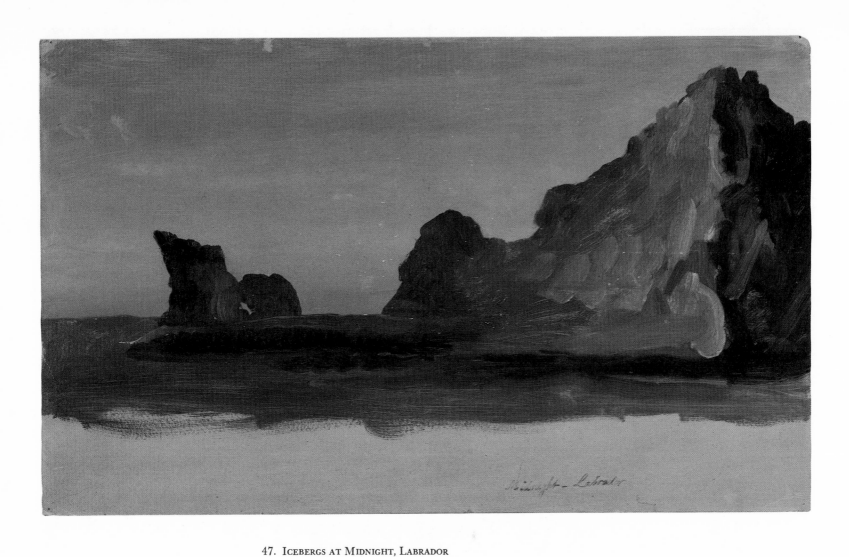

47. ICEBERGS AT MIDNIGHT, LABRADOR

Oil on paperboard; 12 in x 20 in (30.5 cm x 50.7 cm)

Date: 1859, June–July

Inscribed l.r.: "Midnight–Labrador"

Cooper-Hewitt 1917-4-711

Exhibited: Corcoran, 1971, no. 63; Graham, 1974; Amherst–Coe Kerr, 1975, no. 13; Claremont-Wellesley, 1975–1976

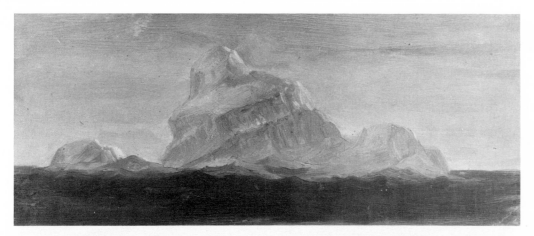

46. ICEBERG AGAINST EVENING SKY

Oil on paperboard; 4⅝ in x 11⅝ in (11.8 cm x 29.7 cm)

Date: 1859, June–July

Cooper-Hewitt 1917-4-731

Exhibited: NCFA–Knoedler, 1966, no. 98; SITES, 1966; Graham, 1974; MOMA, 1976

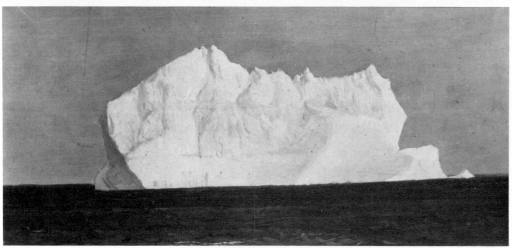

48. MASSIVE ICEBERG

Oil with pencil on paper; 7½ in x 14⅞ in (19.0 cm x 37.7 cm)

Date: 1859, June–July

Inscribed verso: "Iceberg by F. E. Church"

Cooper-Hewitt 1917-4-296A

Exhibited: Graham, 1974; Amherst–Coe Kerr, 1975, no. 14; Claremont-Wellesley, 1975–1976

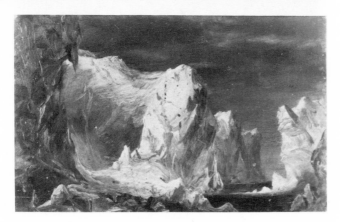

49. STUDY FOR "THE ICEBERGS"

Oil on paperboard; 6⅜ in x 10⅜ in (16.3 cm x 26.3 cm)

Date: ca. 1859

Cooper-Hewitt 1917-4-707

Exhibited: Chicago-Whitney, 1945, no. 33; Corcoran, *American Muse,* 1959, no. 46; Wilmington, 1962, no. 10; NCFA–Knoedler, 1966, no. 105; Graham, 1974; Claremont-Wellesley, 1975–1976

51. Century Plant

Oil with pencil on paperboard; 8½ in x 11¼ in (21.7 cm x 28.5 cm)

Date: 1865, April–August

Cooper-Hewitt 1917-4-675B

Exhibited: Graham, 1974

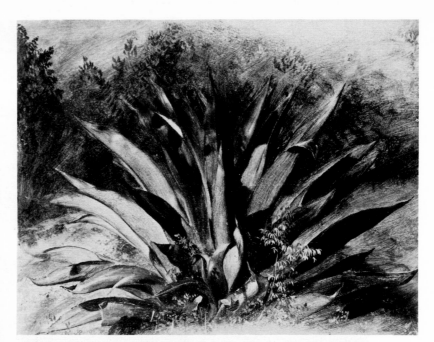

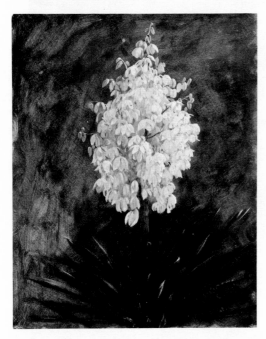

50. Penguin Plant

Oil with pencil on paperboard; 12 1/16 in x 9¾ in (30.6 cm x 24.6 cm)

Inscribed l.r.: "Penguin Jamaica Aug/65"

Cooper-Hewitt 1917-4-676C

52. Philodendron Vines, Jamaica

Oil on paperboard; 11⅞ in x 12¼ in (30.3 cm x 31.1 cm)

Date: 1865, April–August

Cooper-Hewitt 1917-4-679B

Exhibited: Graham, 1974

53. JAMAICAN FLOWERS

Oil on paperboard; 13⅝ in x 15⅝ in (34.5 cm
x 39.8 cm)

Date: 1865, April–August

Cooper-Hewitt 1917-4-679A

Exhibited: Graham, 1974; Claremont-Wellesley,
1975–1976

Bibliography: Young (1959), p. 105

54. TRUMPET TREE

Oil with pencil on paperboard; 11½ in x 6⅞ in
(29.3 cm x 17.6 cm)

Inscribed l.r.: "Jamaica May/65"; *u.l.:*
"Trumpet"; *center:* "Trumpet Tree"

Cooper-Hewitt 1917-4-676A

Exhibited: Graham, 1974

56. TROPICAL VINES

Oil with pencil on paperboard; 12 in x 9 in
(30.5 cm x 22.9 cm)

Inscribed l.l.: "Jamaica May/65"

Cooper-Hewitt 1917-4-342A

Exhibited: Atlanta, Ga., The High Museum
of Art, "The Beckoning Land," 1971, p. 72, no.
50; Ithaca, 1971, no. 5; AFA Circulating Pro-
gram, 1972; Joseloff, 1974, no. 54; Graham, 1974

55. Wild Philodendron on a Tree Trunk

Oil with pencil on paperboard; 11¾ in x 10⅛ in (28.7 cm x 25.5 cm)

Date: 1865, April–August

Cooper-Hewitt 1917-4-393A

Exhibited: Graham, 1974

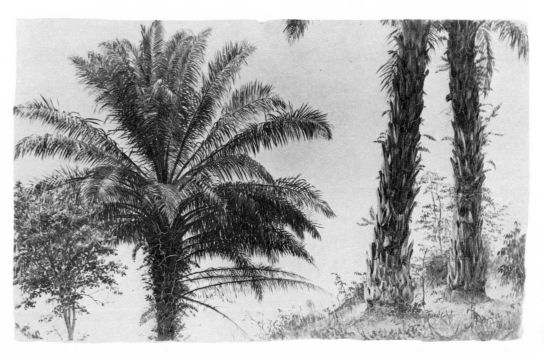

ABOVE, RIGHT:

57. Palm Trees

Oil on paperboard; 12 in x 20 in (30.6 cm x 50.9 cm)

Inscribed l.l.: "Jamaica / June 65"

Cooper-Hewitt 1917-4-743C

RIGHT:

58. Deep Jungle Foliage

Oil on paperboard; 12 in x 19⅞ in (30.4 cm x 50.5 cm)

Date: 1865, April–August

Cooper-Hewitt 1917-4-743B

Exhibited: Detroit, 1944, no. 71; Graham, 1974; Claremont-Wellesley, 1975–1976

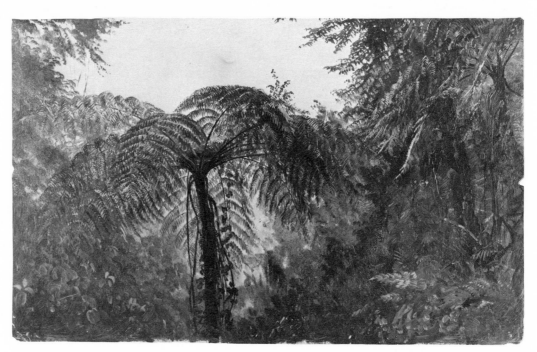

59. RAIN FOREST, JAMAICA

Oil with pencil on paperboard; 12 in x 20 in
(30.5 cm x 50.8 cm)

Date: 1865, April–August

Cooper-Hewitt 1917-4-678B

Exhibited: Claremont-Wellesley, 1975–1976

Bibliography: Steadman (1976), p. 121

BELOW, LEFT:

60. JAMAICAN FOREST

Oil on paperboard; 12 in x 12¾ in (30.5 cm x
32.4 cm)

Date: 1865, April–August

Cooper-Hewitt 1917-4-679C

BELOW, RIGHT:

61. DISTANT HILLS

Oil on paperboard; 4½ in x 4¹¹⁄₁₆ in (11.5 cm x
10.3 cm)

Inscribed l.l.: "Jamaica July 65"

Cooper-Hewitt 1917-4-730

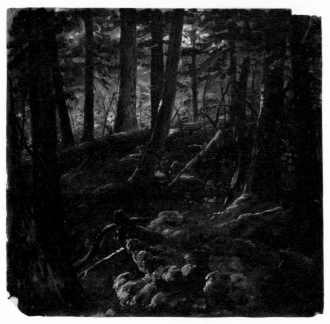

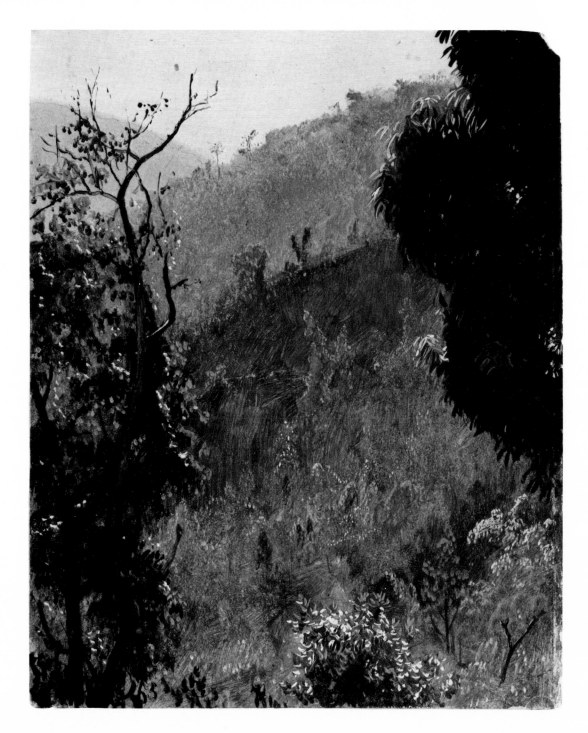

62. HILLSIDES, JAMAICA
Oil with pencil on paperboard; 6 in x 7½ in
(15.2 cm x 19.0 cm)
Inscribed l.l.: "Jamaica July–65"
Cooper-Hewitt 1917-4-673B

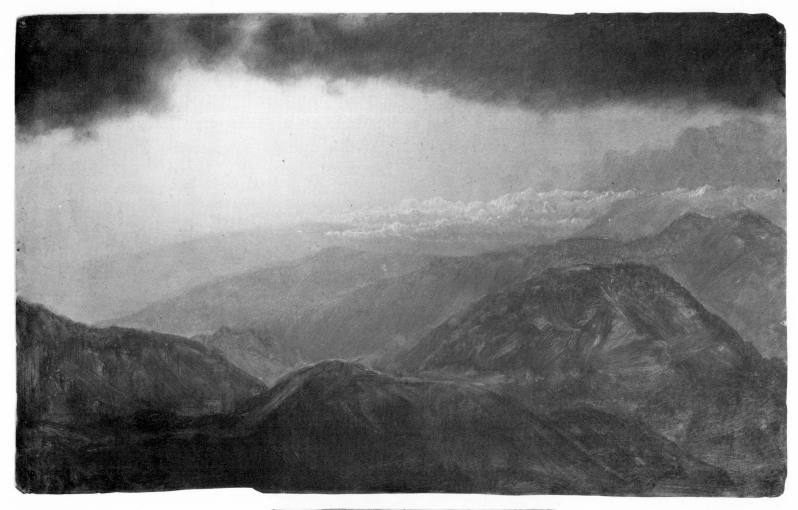

ABOVE:

64. STORM IN THE MOUNTAINS

Oil with pencil on paperboard; 12 in x 19⅞ in
(30.4 cm x 50.5 cm)

Date: 1865, April–August

Cooper-Hewitt 1917-4-351C

Exhibited: Graham, 1974; Claremont-Wellesley,
1975–1976

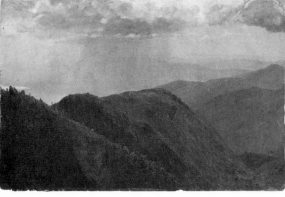

63. MOUNTAINS IN JAMAICA

Oil with pencil on paperboard; 11½ in x 18⅛ in
(29.3 cm x 46.0 cm)

Inscribed l.l.: "Jamaica July 65"

Cooper-Hewitt 1917-4-351A

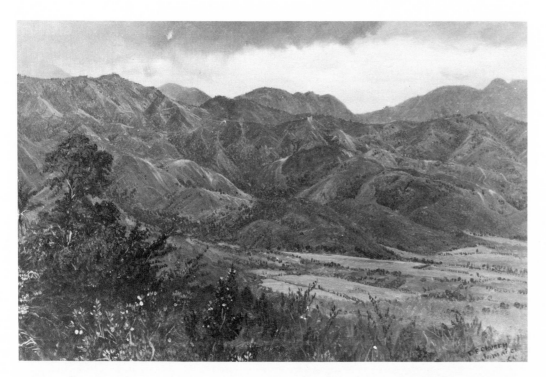

65. Red Hills near Kingston
Oil on paperboard; 9¼ in x 14½ in (23.5 cm x 36.7 cm)
Inscribed l.r.: "F. E. Church Jamaica 65"
Cooper-Hewitt 1917-4-385A
Exhibited: NCFA–Knoedler, 1966, no. 90
Bibliography: Huntington (1966), no. 40

66. Valley and Mountain View
Oil with pencil on paperboard; 12 in x 19⅞ in (30.5 cm x 50.5 cm)
Date: 1865, April–August
Cooper-Hewitt 1917-4-680C

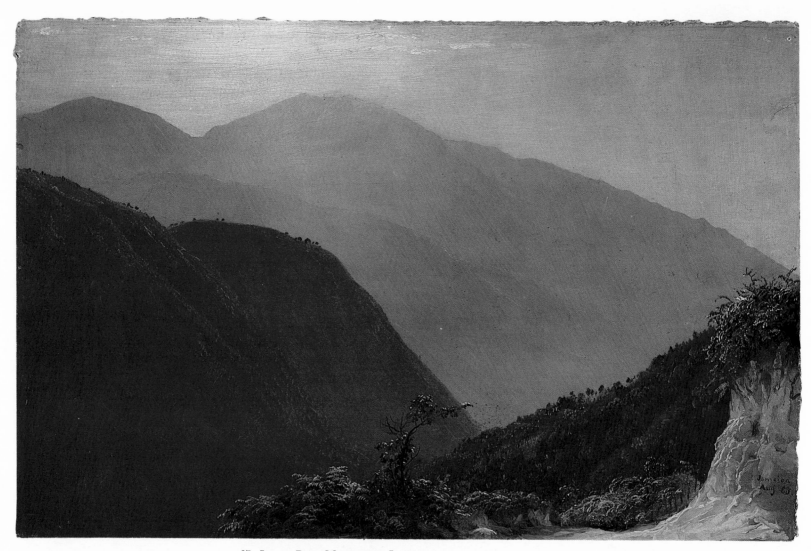

67. IN THE BLUE MOUNTAINS, JAMAICA

Oil on paperboard; 11¼ in x 17⅞ in (29.2 cm
x 45.5 cm)

Inscribed: "Jamaica Aug/65"

Cooper-Hewitt 1917-4-419

Exhibited: NCFA–Knoedler, 1966, no. 91;
SITES, 1966; Joseloff, 1974, no. 57; Graham,
1974; Claremont-Wellesley, 1975–1976

84

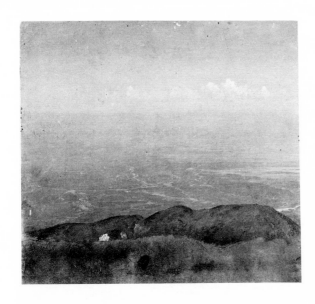

68. THE SEA FROM A HIGH BLUFF

Oil with pencil on paperboard; 10¾ in x 11¹³⁄₁₆ in (27.4 cm x 30.0 cm)

Date: 1865, April–August

Cooper-Hewitt 1917-4-1331C

69. PALISADES NEAR KINGSTON

Oil with pencil on paperboard; 10¼ in x 12 in (26.0 cm x 30.5 cm)

Date: 1865, April–August

Cooper-Hewitt 1917-4-394B

Exhibited: NCFA–Knoedler, 1966, no. 89; Graham, 1974

Bibliography: Huntington (1966), no. 88

70. THUNDERHEADS, JAMAICA

Oil on paperboard; 7⅛ in x 11⅜ in (18.2 cm x 29.4 cm)

Date: 1865, April–August

Cooper-Hewitt 1917-4-407B

Exhibited: Joseloff, 1974, no. 56; Graham, 1974; Claremont-Wellesley, 1975–1976

Bibliography: Steadman (1976), p. 117

73. SUNSET, JAMAICA

Oil on paperboard; 10⅛ in x 12 in (25.7 cm x 30.6 cm)

Inscribed: "Jamaica Aug/65"

Cooper-Hewitt 1917-4-409B

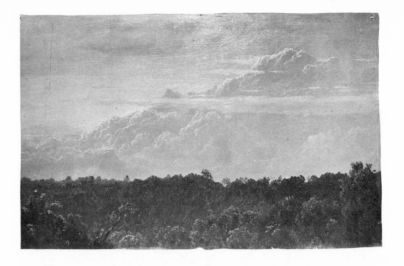

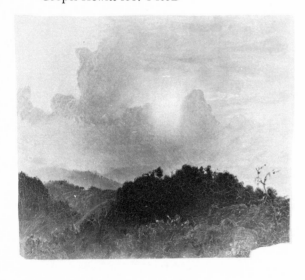

71. CLOUD STUDY, JAMAICA

Oil with pencil on paperboard; 9½ in x 11¹⁵⁄₁₆ in (24.2 cm x 30.3 cm)

Date: 1865, April–August

Cooper-Hewitt 1917-4-682B

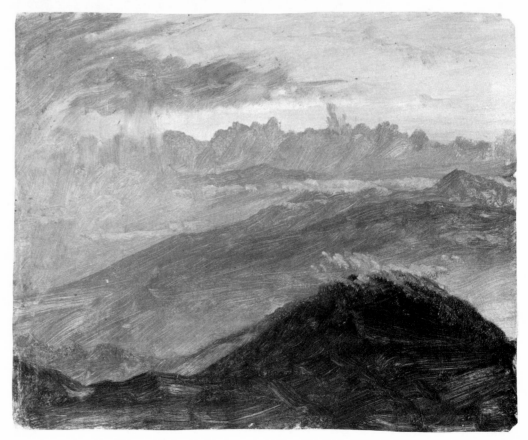

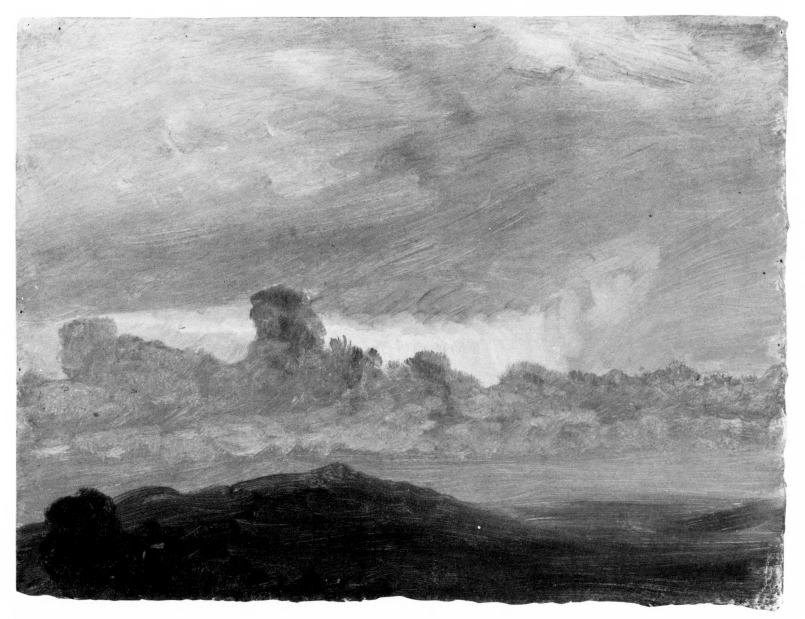

72. ORANGE SUNSET
Oil on paperboard; 8⅜ in x 11¼ in (21.2 cm x 28.7 cm)
Inscribed l.l.: "Jamaica Aug–65"
Cooper-Hewitt 1917-4-408B
Exhibited: Graham, 1974

75. FIGURE SKETCHES IN ARABIA

Oil on paperboard; 11⅞ in x 18⅝ in (30.2 cm x 47.2 cm)

Date: 1868

Cooper-Hewitt 1917-4-801

Exhibited: Graham, 1974; Claremont-Wellesley, 1975–1976

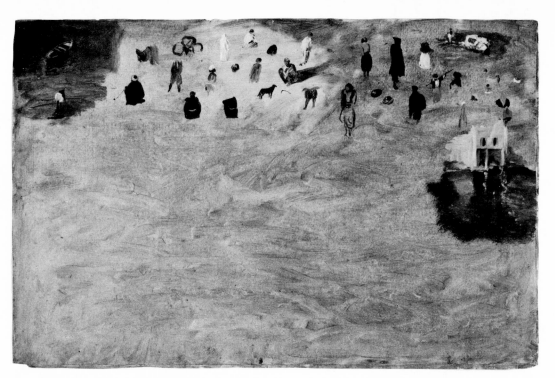

74. STANDING BEDOUIN

Oil on paper; 13⅞ in x 10¼ in (35.3 cm x 26.2 cm)

Date: 1868

Cooper-Hewitt 1917-4-752A

Exhibited: NCFA–Knoedler, 1966, no. 116; SITES, 1966; Ithaca, 1971, no. 9; AFA Circulating Program, 1972; Graham, 1974; Claremont-Wellesley, 1975–1976

Bibliography: Steadman (1976), p. 122

76. CROUCHING DROMEDARY

Oil with pencil on paperboard; 11⅞ in x 18½ in
(30.0 cm x 47.0 cm)

Date: 1868

Cooper-Hewitt 1917-4-492

Exhibited: NCFA–Knoedler, 1966, no. 118;
Graham, 1974

Bibliography: Huntington (1966), no. 77

77. YEMEN VALLEY

Oil with pencil on paperboard; 13 in x 20 in
(32.9 cm x 50.8 cm)

Date: 1868, February

Cooper-Hewitt 1917-4-844

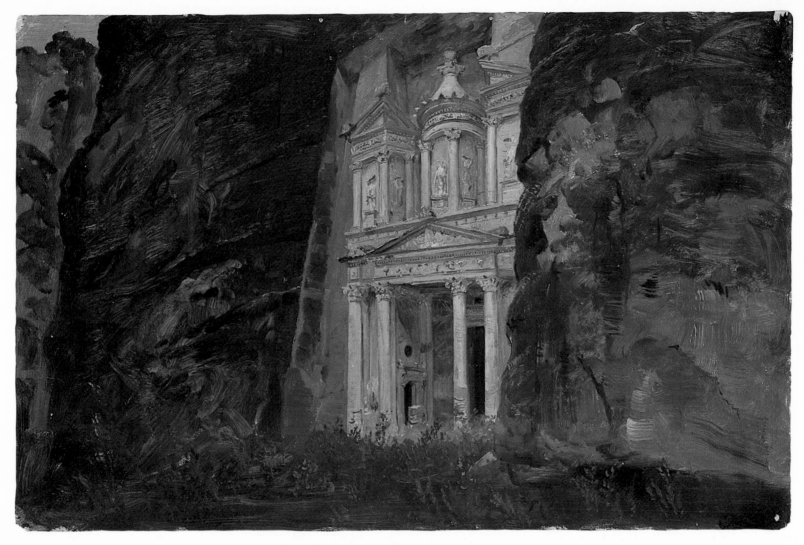

78. El Khazneh, Rock Tomb at Petra

Oil with pencil on paperboard; 13 in x 20⅛ in
(32.9 cm x 51.0 cm)

Date: 1868, February

Cooper-Hewitt 1917-4-485A

Exhibited: NCFA–Knoedler, 1966, no. 112;
SITES, 1966; Graham, 1974; Claremont-
Wellesley, 1975–1976

Bibliography: Steadman (1976), p. 118

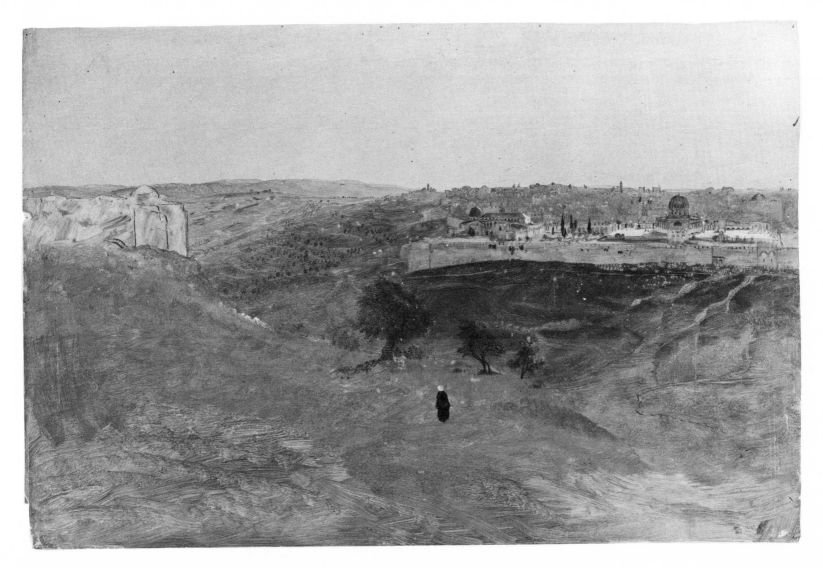

79. VIEW OF JERUSALEM

Oil with pencil, pen and ink on paperboard;
13 in x 20⅛ in (32.9 cm x 51.0 cm)

Date: 1868, April

Cooper-Hewitt 1917-4-763

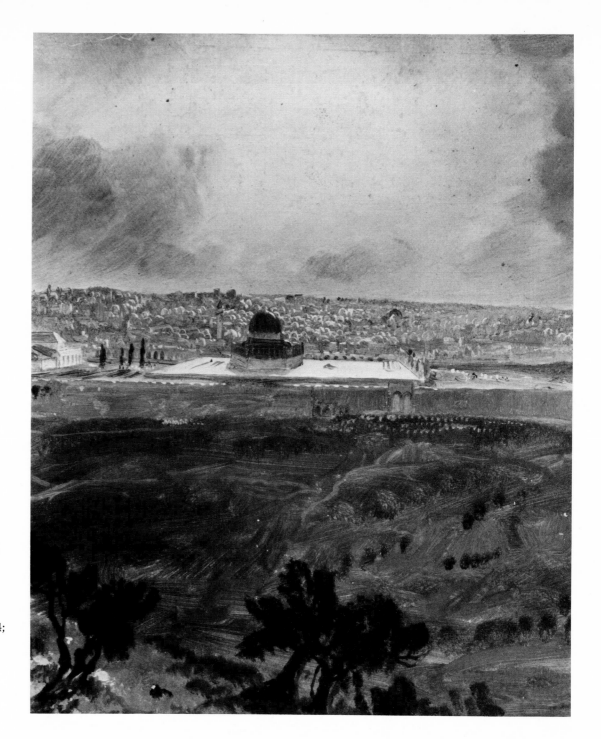

80. Jerusalem from the Mount of Olives

Oil with pencil on paperboard; 11⅞ in x 18½ in (30.0 cm x 47.0 cm)

Date: 1868, April

Cooper-Hewitt 1917-4-341

Exhibited: Chicago-Whitney, 1945, no. 35; NCFA–Knoedler, 1966, no. 115; Graham, 1974; Claremont-Wellesley, 1975–1976

81. Ruins at Baalbek:
 The Temple of Bacchus

Oil with pencil on paperboard; 10 in x 11¼ in
(25.4 cm x 28.6 cm)

Date: 1868, May

Cooper-Hewitt 1917-4-581

Exhibited: Wilmington, 1962, no. 9; NCFA–
Knoedler, 1966, no. 120; SITES, 1966; Graham,
1974; Claremont-Wellesley, 1975–1976

Bibliography: James Thomas Flexner, *That
Wilder Image* (New York, 1962), p. 166, fig. 39;
Huntington (1966), no. 80; Steadman (1976),
p. 119

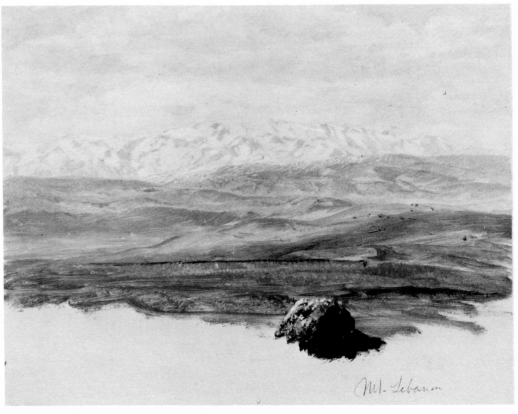

82. Mount Lebanon, Syria

Oil on paperboard; 10 in x 12¾ in (25.4 cm x
32.4 cm)

Date: 1868, May

Inscribed l.r.: "Mt. Lebanon"

Cooper-Hewitt 1917-4-758A

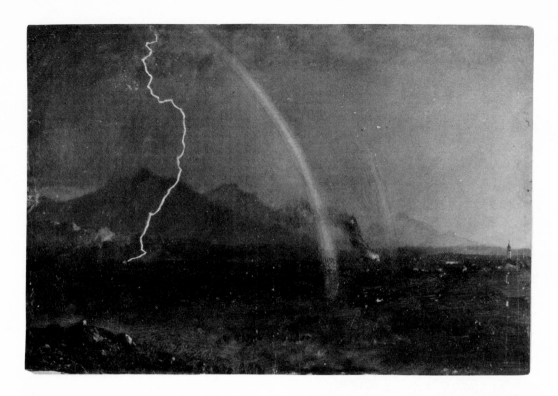

83. Thunderstorm in the Alps

Oil with pencil on paperboard; 11⅝ in x 17½ in (29.4 cm x 44.5 cm)

Date: 1868, August

Cooper-Hewitt 1917-4-509

Exhibited: Graham, 1974; Claremont-Wellesley, 1975–1976

84. The Watzmann and the Hochkalter near Berchtesgaden, Bavaria

Oil with pencil on paperboard; 12¾ in x 19⅞ in (32.5 cm x 50.5 cm)

Date: 1868, June–July

Cooper-Hewitt 1917-4-493

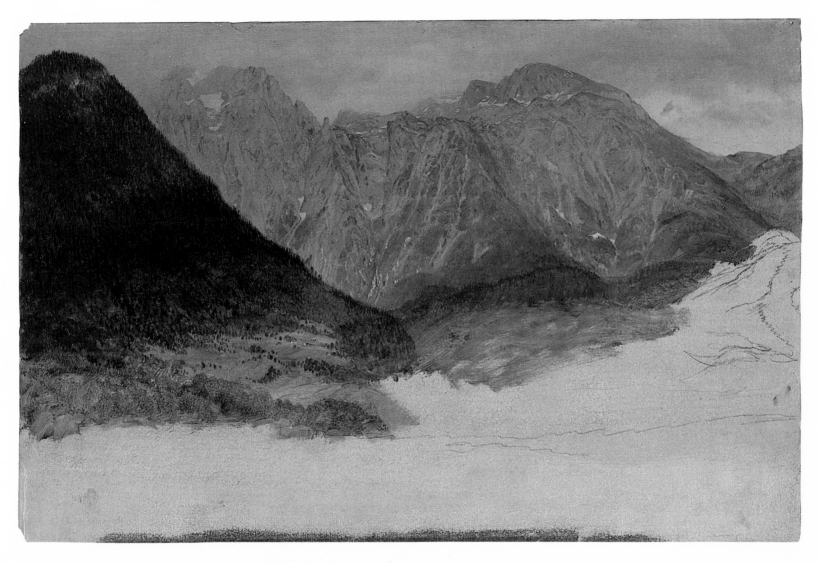

85. ALPINE VALLEY

Oil on paperboard; 12¾ in x 19¾ in (32.4 cm
x 50.2 cm)

Date: 1868

Cooper-Hewitt 1917-4-1131

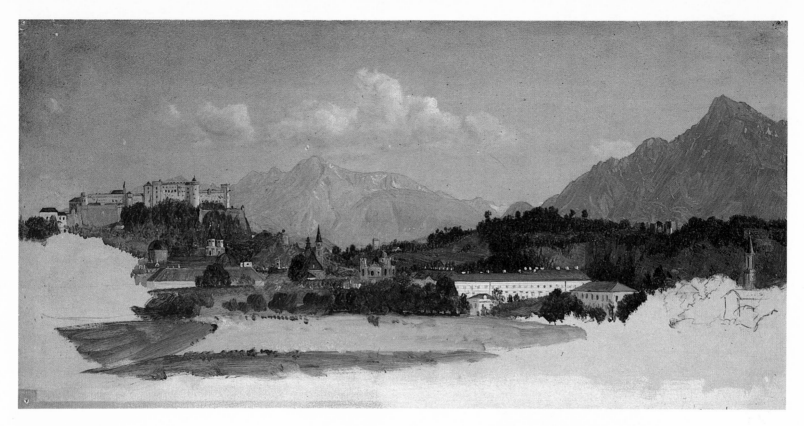

87. VIEW OF SALZBURG

Oil with pencil on paperboard; 12⅞ in x 20⅛ in
(32.6 cm x 51.0 cm)

Date: 1868, July

Inscribed l.r.: "oil mix/jades (?) /Lem yel"

Cooper-Hewitt 1917-4-303B

Exhibited: Chicago-Whitney, 1945, no. 29;
Graham, 1974; Claremont-Wellesley, 1975–1976

86. THE CASTLE AT SALZBURG

Oil with pencil on paperboard; 12¾ in x 19⅞ in
(32.5 cm x 50.6 cm)

Date: 1868, July

Cooper-Hewitt 1917-4-303A

Exhibited: NCFA–Knoedler, 1966, p. 125;
SITES, 1966; Ithaca, 1971, no. 12; AFA Circu-
lating Program, 1972; Graham, 1974; Claremont-
Wellesley, 1975–1976

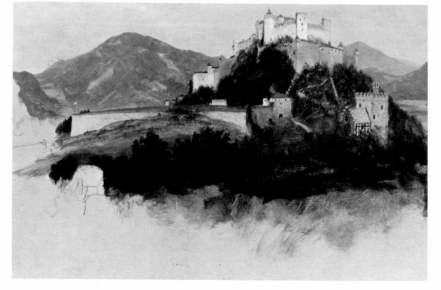

88. Unfinished View of a City

Oil with pencil on paperboard; 12⅜ in x 16⅝ in (31.6 cm x 42.3 cm)

Date: 1868

Cooper-Hewitt 1917-4-1297

Exhibited: Graham, 1974

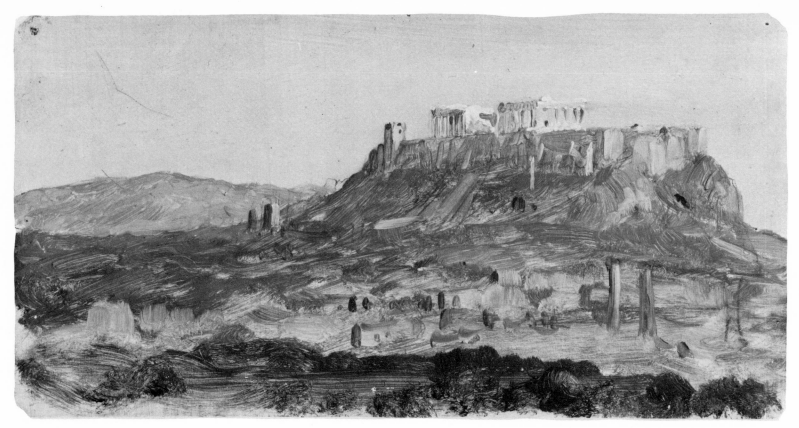

90. VIEW OF THE ACROPOLIS, SUNRISE

Oil with pencil on paperboard; 4½ in x 8⅞ in
(11.4 cm x 22.6 cm)

Date: 1869, April

Cooper-Hewitt 1917-4-507A

89. THE PARTHENON FROM THE SOUTHEAST

Oil with pencil on paperboard; 8⅞ in x 12⅞ in
(22.6 cm x 32.8 cm)

Date: 1869, April

Cooper-Hewitt 1917-4-507B

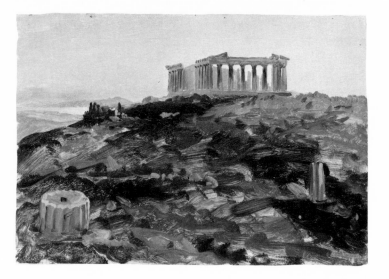

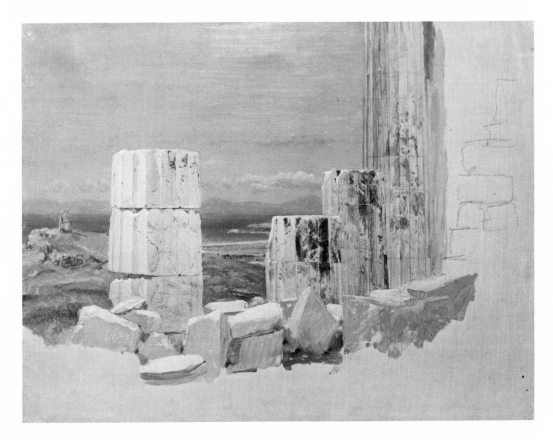

91. BROKEN COLUMNS, VIEW FROM THE
 PARTHENON

Oil with pencil on paperboard; 11⅛ in x 15 in
(28.3 cm x 38.1 cm)

Date: 1869, April

Cooper-Hewitt 1917-4-573C

Exhibited: New York, New York University Art
Collection, Marlborough-Gerson Gallery, "The
New York Painter," Sept. 26–Oct. 14, 1967;
Claremont-Wellesley, 1975–1976

Bibliography: Huntington (1966), no. 75

92. BASE OF A CAPITAL, DIONYSIUS THEATRE,
 ATHENS

Oil with pencil on paperboard; 10⅛ in x 13 in
(25.6 cm x 32.9 cm)

Date: 1869, April

Cooper-Hewitt 1917-4-580

Exhibited: NCFA–Knoedler, 1966, no. 134

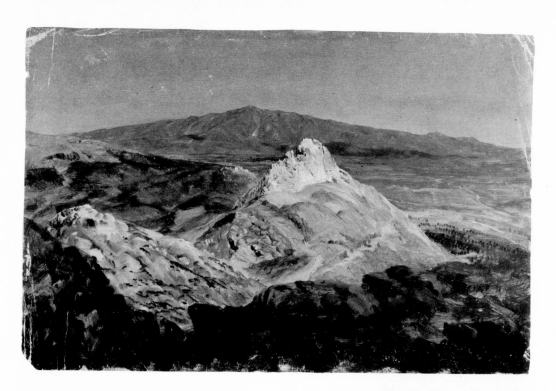

93. MOUNT PENTELICUS

Oil on paperboard; 12⅞ in x 20 in (32.8 cm x 50.8 cm)

Inscribed l.r. center: "Pentelicus/69"

Gift of Eliot C. Clark, 1953-133-1

Exhibited: Graham, 1974; Claremont-Wellesley, 1975–1976

94. ROCKY HILLTOP

Oil with pencil on paperboard; 9⅞ in x 11 in (25.0 cm x 28.0 cm)

Date: 1869

Cooper-Hewitt 1917-4-326

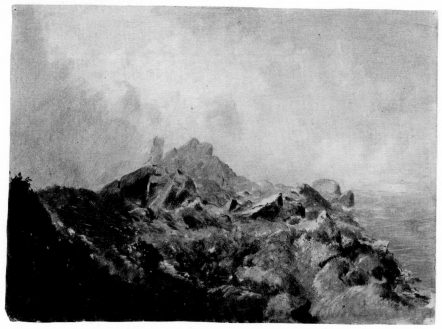

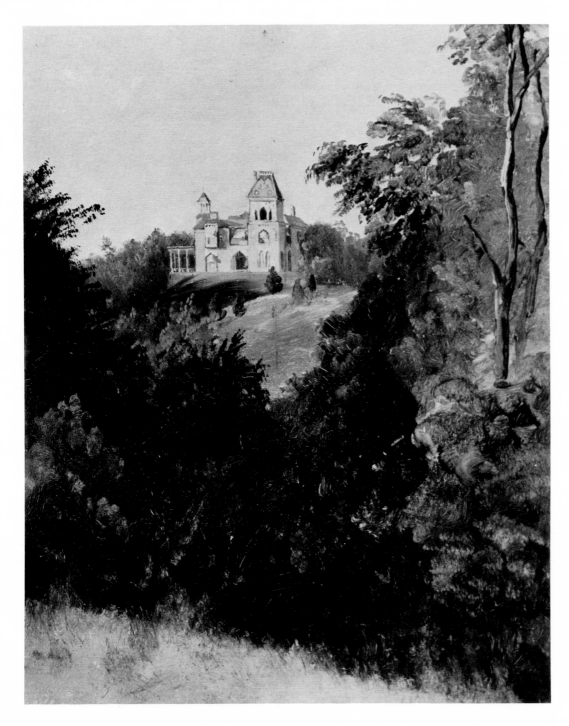

95. VIEW OF OLANA

Oil on paperboard; 12⅛ in x 9½ in (30.9 cm x 24.2 cm)

Date: ca. 1872

Cooper-Hewitt 1917-4-666

Exhibited: NCFA–Knoedler, 1966, no. 55; Ithaca, 1971, no. 14; AFA Circulating Program, 1972; Graham, 1974; Claremont-Wellesley, 1975–1976; Grand Rapids Art Museum, Mich., "Themes in American Painting," 1977, p. 118, pl. 56

Bibliography: Joan Patterson Kerr, "Olana," *American Heritage* 26:5 (August 1975): 42.

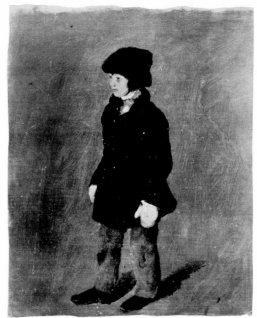

96. PORTRAIT OF A BOY

Oil with pencil on canvas; 10⅜ in x 8¼ in (26.4 cm x 20.9 cm)

Date: ca. 1870–75

Cooper-Hewitt 1917-4-344

Exhibited: Graham, 1974; Claremont-Wellesley, 1975–1976

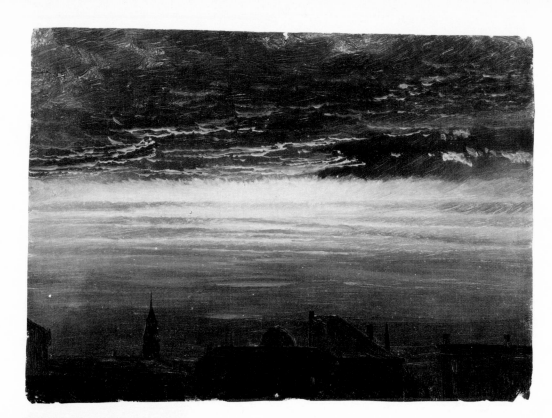

97. HUDSON, NEW YORK, AT TWILIGHT

Oil on canvas; 8⅞ in x 12½ in (22.5 cm x 31.8 cm)

Date: ca. 1860–65

Cooper-Hewitt 1917-4-1346B

Exhibited: Graham, 1974; Claremont-Wellesley, 1975–1976

98. MOONLIGHT

Oil on composition board; 12 in x 16 in (30.5 cm x 40.8 cm)

Date: 1860–65

Cooper-Hewitt 1917-4-1319A

99. HIGH CLOUDS ACROSS THE HUDSON

Oil on paperboard; 11⅛ in x 15¼ in (28.2 cm x 38.7 cm)

Inscribed l.r.: "June/70"

Cooper-Hewitt 1917-4-582A

Exhibited: Graham, 1974; Claremont-Wellesley, 1975–1976

Bibliography: John K. Howat, *The Hudson River and Its Painters* (New York: Viking Press, 1972), pl. 76

100. SUNSET IN THE HUDSON VALLEY

Oil on paperboard; 12 in x 20 in (30.4 cm x 50.7 cm)

Date: 1870–75

Cooper-Hewitt 1917-4-864

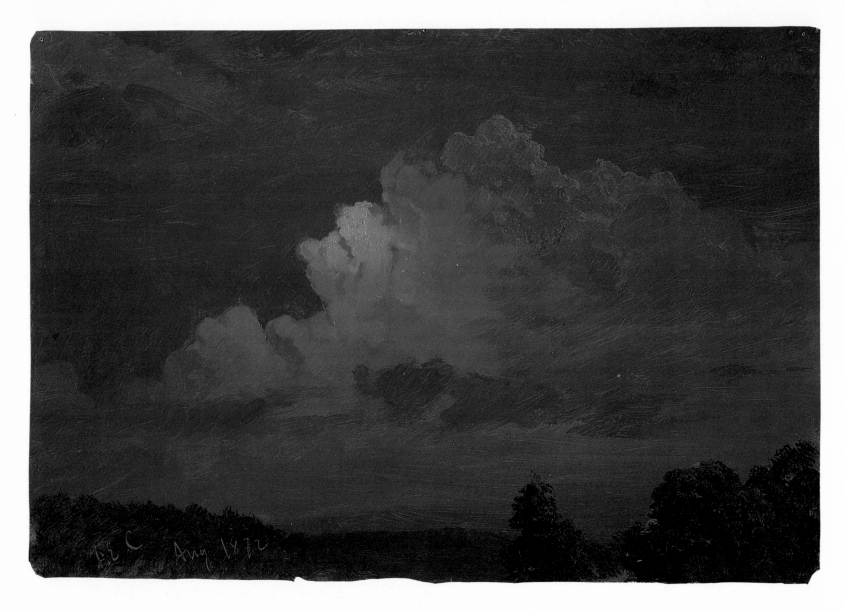

101. Nightfall near Olana

Oil on paperboard; 9½ in x 14⅛ in (24.2 cm x 35.8 cm)

Inscribed l.l.: "FEC Aug. 1872"

Cooper-Hewitt 1917-4-587

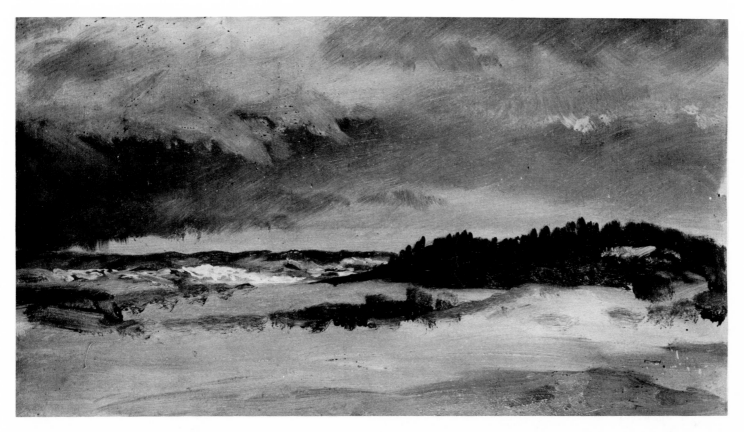

102. WINTER LANDSCAPE AT SUNSET

Oil on paperboard; 6⅞ in x 12⅛ in (17.4 cm x 30.9 cm)

Date: ca. 1870–75

Cooper-Hewitt 1917-4-45

103. WINTER LANDSCAPE, FULL MOON

Oil on paperboard; 5⅜ in x 8¼ in (13.7 cm x 21.0 cm)

Date: ca. 1870–75

Cooper-Hewitt 1917-4-733

105. CLOUD STUDY, ABOVE WINTER LANDSCAPE

Oil on composition board; 11¼ in x 16 in (28.6 cm x 40.5 cm)

Date: ca. 1870–75

Cooper-Hewitt 1917-4-1363

107. ORANGE SKY AT SUNSET

Oil on paperboard; 9⁵⁄₁₆ in x 12 in (23.6 cm x 30.4 cm)

Date: ca. 1870–75

Cooper-Hewitt 1917-4-1366

BELOW, LEFT:

104. TREE AND SKY, DISTANT VIEW

Oil on canvas; 6¼ in x 10⅝ in (16.0 cm x 27.0 cm)

Date: ca. 1870–75

Cooper-Hewitt 1917-4-1354

BELOW, RIGHT:

106. WINTER LANDSCAPE, MOONLIGHT

Oil on paperboard; 6⅝ in x 11⅛ in (16.9 cm x 28.3 cm)

Date: ca. 1870–75

Cooper-Hewitt 1917-4-420

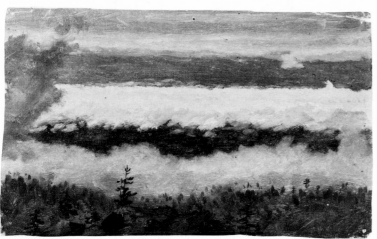

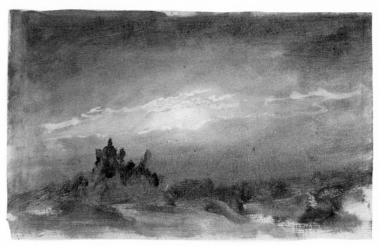

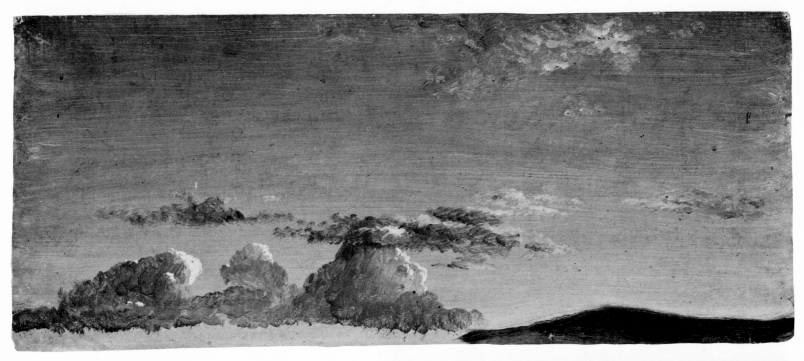

108. Clouds above the Horizon

Oil on composition board; 6⅝ in x 16 in (16.7 cm x 40.7 cm)

Date: ca. 1870–75

Cooper-Hewitt 1917-4-557A

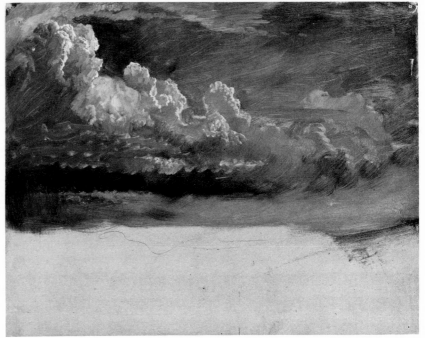

109. Cloud Study, Yellow Sunset

Oil on paperboard; 10⅛ in x 13 in (25.7 cm x 32.9 cm)

Inscribed verso: "Splendid deep purple blue/ Bank yellow brown/6 purple grey darkish/ edges clearly lighted/2 rich yellow/3 Dazzling orange spot cloud/7 luminous green/grey cool 4 rich reddish orange softened/not strongly defined/5 less bright. March 1871"

Cooper-Hewitt 1917-4-586

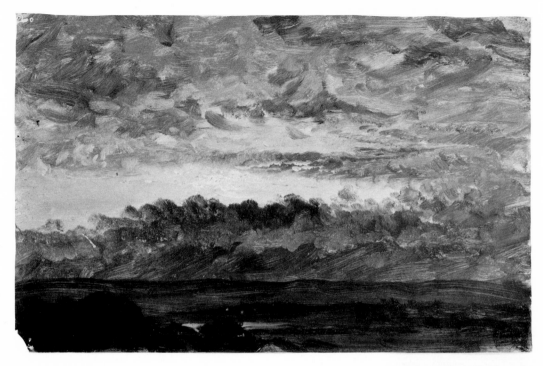

110. SUNSET STUDY

Oil on paperboard; 9 in x 14¼ in (22.8 cm x 36.3 cm)

Date: ca. 1870–75

Cooper-Hewitt 1917-4-310

Exhibited: Graham, 1974; Claremont-Wellesley, 1975–1976

111. AFTER TWILIGHT: COLOR EFFECTS

Oil on paperboard; 11¹¹⁄₁₆ in x 14⅜ in (28.1 cm x 36.5 cm)

Date: 1870–80

Cooper-Hewitt 1917-4-1357

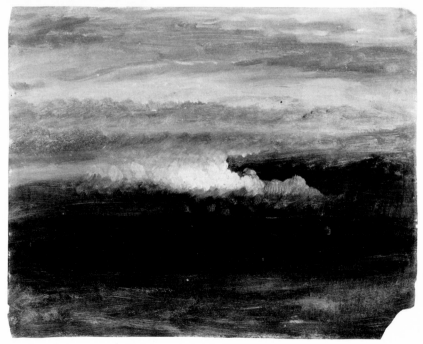

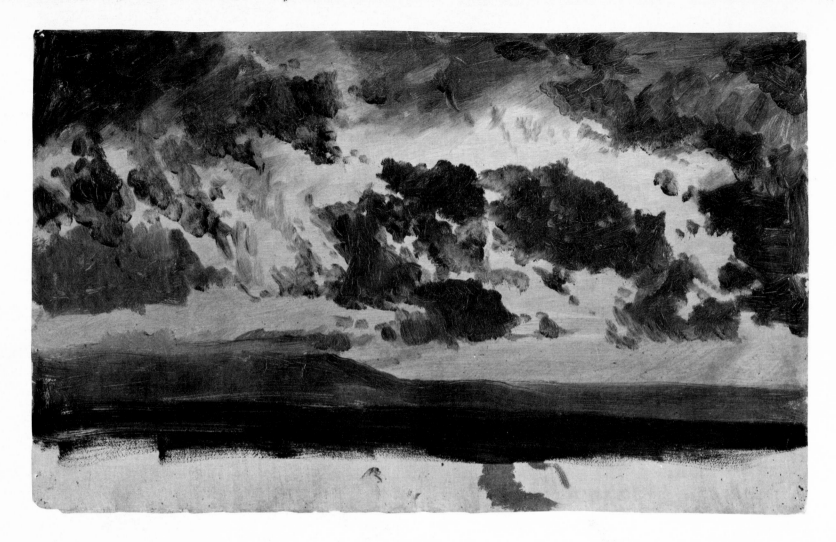

112. Sunset, Color Effects

Oil on paperboard; 11⅞ in x 20 in (30.3 cm x 50.9 cm)

Date: 1870–80

Cooper-Hewitt 1917-4-382

Exhibited: Graham, 1974; Claremont-Wellesley, 1975–1976